FOCAL CINEBOOKS

J. D. Beal

How to Make

FILMS AT SCHOOL

FOCAL PRESS

London and New York

Printed and bound in Great Britain by
STAPLES PRINTERS LIMITED
at their Rochester, Kent, establishment

Contents

Preface

When a film made at a Scottish school was selected by the adjudicator as the outstanding entry in the 1961 Scottish Amateur Film Festival—which is open to international entries—there was, understandably perhaps, some raising of eyebrows, particularly in view of the established reputations of some of the amateur film-makers who had sent films for consideration, but the adjudicator, Sydney J. Furie, had no doubts about his decision. The winning film, he declared, showed originality of thought and treatment and an imaginative use of the medium which fully justified the award.

School-made films had been entered in the Scottish Amateur Festival on several previous occasions, but the recognition accorded to this film—"L'Inspecteur"—undoubtedly served as an encouragement to other schools "to go and do likewise". The first triumph for a school-made film was followed by another two years later when an English film—"Strike"—was awarded the Festival's major trophy by Ken Annakin. Since then the Scottish Film Council has, in fact, included in its annual Festival a special class for school productions. The number of entries in this class remains comparatively small, but it has been a source of great encouragement to the organizers to note how the range of subjects tackled has widened and how standards have risen year by year.

Even so, it is probable that the total number of films made in British schools since the war does not exceed 500—a U.N.E.S.C.O. report published in 1963 put the figure at that date at about 300—despite all the efforts made to encourage both teachers and pupils to embark upon film

production as a school project. A few years earlier a Scottish survey indicated that probably not more than ten films had been produced at Scottish schools in that time—that is, films that attempted something more than merely providing a record, soon to be dated, of a school's sports day or of an outing to the hills, the seaside or a zoological park.

It may well be asked—Why should schools make films? What purpose, if any, does this activity serve? If a purpose is in fact served, what are the requirements? How do you go about making a film? What will the cost be? Who foots the bill? What are the snags? How do you overcome them?

The answers to these—and many other relevant questions —will be found in David Beal's book. Every problem that might face the teacher and his class about to embark on their first production is answered here, from the A.B.C. of finance to the technicalities of adding a sound track to a film.

What David Beal has written in a bid to help others is based on his own experience in learning the art of film-making the hard way, and in looking over the shoulders of pupils in his own school in Lanarkshire when they were making films. His advice should ease the problems of all who would like to venture into this field.

To revert for a moment to the first question, the key question in the minds of many teachers—Why should schools make films?—the answer is quite simple. We live in an age when pupils are under the influence of television, films, radio and records to a degree never before experienced, yet the school curriculum pays scant regard either to the effect on pupils of these mighty media of mass communication or to the need to encourage them, not to accept passively everything set before them, but to apply some thought to what they see and hear, and to build up their own standards of appreciation and values. This is where film-making at school has a most important part to play in the educational service.

As far back as 1950—before television had become so

dominating a factor in everyday life as it is today—the Wheare Committee declared, "The first need is for more teachers to equip themselves with a better knowledge of the cinema". About the same time the Scottish Education Department, in Circular No. 188, expressed the hope that "headmasters will develop interests for their pupils outwith curricular subjects". Film-making, wherever it has been tried, has been found to be a most rewarding and stimulating activity. It captures the imagination of pupils, gives them an opportunity to assist in the creation of something they can understand and evaluate, and provides in the end a sense of achievement not so readily available in other ways to many pupils.

Over the years a great deal of lip service has been paid to the virtues of film-making as a school activity, but lack of "know-how" may have been one of the obstacles to greater development of this enterprise. With the publication of David Beal's book that objection is no longer valid. I commend it to beginners in the field—and to others with some experience as well—as an invaluable handbook on the art of producing a school film.

D. M. ELLIOT
Director, Scottish Film Council

Trends and Aims

The educational scene was never in such a state of flux as it is today. The ferment of activity at this transitional stage among teachers and educationists, schools and pupils is almost equally matched by a ferment of controversy as to the wisdom of some or all of these changes.

At a time when the comprehensive idea is becoming more and more an accepted fact, much thought is being given to ways to making education in the mind of the average child a key to fulfilment and not a rude word.

It is generally agreed that if most pupils approaching the age of fifteen become filled with a passionate longing for the leaving date, there must be something wrong. This feeling is perhaps understandable in the minority of pupils who are either delinquent or simply bone lazy, and will obviously make very little of any form of employment into which they are pitchforked after school. It is distressing, however, when we find this impatient, frustrated, aimless atmosphere among eager and alert young people.

Projects

Much has been done in many schools to correct this tendency. A large number of teachers have made energetic and sometimes highly ambitious efforts to present pupils with a series of challenges to overcome, mysteries to unravel, assignments to undertake and projects to accomplish, always with the aim of kindling interest, stirring up latent initiative and channelling dulled or pent-up energies in a positive and purposeful direction. The accent is increasingly on the twin themes of activity and a common purpose. The time spent in passive assimilation of long lists

10

of facts is cut to an absolute minimum. The keynote instead is the energetic searching by each pupil, working singly or in a group, for information to incorporate in a major project.

With this approach the concept of learning a subject becomes ever more unreal and unnecessary. Life is not divided into watertight subjects. Each interest is part of a universal whole, and the more pupils are encouraged to stir themselves and investigate their environment, with a teacher's guidance, the more they find, often to their astonishment, that all subjects constantly overlap and coalesce.

The most successful projects are generally those which involve many, or even all, parts of the school curriculum, from algebra to zoology. If the average pupil finds that, in the last few terms of his or her school career, all the different aspects of school work are now revealed as part of a lively and meaningful whole, then the school is no longer a tedious, mechanical, monotonous and pointless bore, but a gateway to the enticing vista of the great world outside.

All this, of course, concerns the standard pupil much more than his or her academic counterpart. In either case a teacher is faced with the urgent necessity of arousing the pupil's interest. But with an academic student, whether he or she attends a grammar school (senior secondary in Scotland) or a comprehensive one, there is the stark and inescapable prospect of the external examination at the end of the course. Much of the academic pupil's education must be aligned to this and examinations that lead up to it. With him, it is far less easy to make experiments using activity methods within school hours.

With the great majority of boys and girls, however—standard or non-academic, attending either a secondary modern or technical school (junior secondary in Scotland) or perhaps a comprehensive one—we can feel free to move right away from the conventional subject curriculum. All too often this is only a pale imitation of an academic course.

11

Work at assignments and projects which ruthlessly break up the official time-table may prove more worthwhile and bring together many or all of the school's departments.

Educational Films

A very large number of teachers with average pupils have made extremely successful use of visual and aural aids which present the world to children in a vivid and colourful way. Modern science has here become the servant of education, and the film, particularly, has become a most important asset.

It is when the first novelty of watching educational films in school has worn off that this type of visual aid begins to reveal its value. When each pupil accepts the relevant film in the same way as he accepts the relevant reference book, he is much more likely to learn from it and profit by it.

Most children learn visually much more quickly and effectively than aurally, although in a film an imaginatively-produced sound track is of great assistance in giving meaning to an otherwise puzzling sequence.

There is nowadays a remarkably wide choice of educational films for schools. Most of these fulfil their purpose well, whether produced purely for teaching purposes or made available, often free of charge, by firms and national undertakings. Some of the commercially sponsored films are extremely well produced, and many contain little or no advertising matter. But it is usually advisable for the teacher to see the film first, to make sure that it is of genuine educational value. This preliminary viewing is necessary also for the specifically educational film, as the teacher has to be able to direct his pupils' thoughts to the matter dealt with by the film before they see it. The film can then become a natural and integral part of the term's work.

Many teachers who possess their own amateur ciné equipment have toyed with the idea of making educational films of their own. Some have made a success of this, though very often to a rather limited extent.

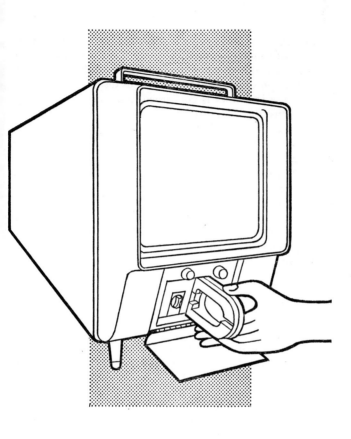

A typical loop-cassette projector. The film, with a maximum running time of four minutes, is permanently sealed in a plastic cassette. No threading is required. The back projection system provides a bright screen image even when viewed in daylight.

13

A teacher may have come home from a colourful holiday, in his own country or abroad, with a holiday film which he is all too anxious to show his friends. In many cases, however, these productions have the serious disadvantage, as far as their use in school is concerned, that they are basically family films. Such films are not really suitable for teaching purposes as they stand.

The best idea would probably be to edit the shots taken on holiday into several short films rather than attempt one omnibus production. These short films would have more coherence, as each would deal concisely with a separate theme. Long holiday epics can be shapeless and often extremely tedious to an audience, such as a school class, which is not acquainted with the family. In any case, many holiday films are designed to be more entertaining than educative.

Film Loops

The best policy for the home-made educational film would seem to be the shorter the better. This is exemplified by the highly successful use of silent 8 mm. loop-cassette projectors, which show very brief film sequences using an automatic back-projection system. Some teachers find it possible to supplement the stock of commercially-produced short films for this type of machine with sequences of their own making, dealing with any short feature or process, from swimming strokes to knitting. Services are available to cope with the duplicate printing and cassette loading aspects of school-produced loop movies.

Such a teaching film may or may not be put together with the co-operation of pupils. But if any pupils do take part, they are likely to be specially selected and particularly able boys and girls, rather than whole classes, and the filming will probably be done outside school hours.

Topics dealt with need not be within the school environment, and some of the most useful might well be filmed by a teacher on a solitary motoring excursion at the weekend.

14

Thus the actual making of this type of film would not normally be part of a school project.

Suitable subjects for the amateur educational film spring readily to mind. They include local study (historical, geographical and cultural); poetry (a poem read on the sound track and illustrated on film); civic and ethical education (including road safety, tidiness and courtesy); demonstration sequences (involving techniques used in scientific, technical, domestic, artistic and physical education); and sequences illustrating aspects of life in the home country or in a foreign land.

The true worth of many of these film sequences lies in their ability to show techniques or environments which cannot be brought into the classroom.

Filming Activities

Filming students' day-to-day activities, at school and elsewhere, serves a somewhat different purpose. Many schools make only this type of film, and again it is generally made by a teacher assisted by the students. This is primarily a school record.

Children can, for instance, be filmed at work in various classes, or arriving at school, having lunch and leaving for home. Several sequences may be combined to show a typical day or year at school. Extra-curricular activities may also be featured. Obvious examples are the annual school sports meeting, the Saturday football or hockey match, a school concert, the Christmas party, episodes from a school play, a flower show, and highlights from the prize-giving ceremony.

A production compiled from these activities could be presented to parents, former pupils and friends as an annual school newsreel.

A school outing is one of the best opportunities for a record film, especially if it is to a distant locality. Here the teacher may find the filmed record of distinct educational value.

If a number of the pupils are going on an educational excursion to a place of historical, geographical, literary or scientific interest, it is particularly worthwhile for the teacher to make a film of the outing. The results can be shown later to other classes who have not had the opportunity to visit that particular place, which might be a town, castle, or hydro-electric scheme. Thus the pupils' horizon may be widened in a natural and entertaining way.

When members of the school staff go to the length of conducting a group of children to the Continent, it seems a pity if they do not take the chance of filming that adventurous journey. However, the matter requires a considerable amount of thought beforehand, so that the film will emerge as a logical piece of work. The danger, if the film is not properly put together, is of ending up with a scrappy and disjointed set of events.

Opening sequences can be filmed long before the date of departure. Teachers can be shown studying maps and time-tables. The school notice-board announces details of the excursion. Pupils can be seen attending special meetings where they learn a little of the geography and language of the country they are to visit. Then, as shots of a changing calendar show the rapid approach of the great day, students will be seen making last-minute preparations.

An attempt to show parts of the actual journeys there and back will improve the film. There should be brief shots of notice-boards on railway stations and signposts at road sides, so that not too much explanation is required.

When the various places visited by the party are being filmed, as much life and movement should be included as possible.

An excursion film may develop into a much more elaborate and polished affair than at first expected, especially if well-designed captions and a lively sound track are added after the final editing. Such matters will be dealt with in later chapters.

Films recording pupils' activities, such as those we have

just discussed, are certainly well worth making. A well-made record film may have considerable value as the centre-piece of a successful and fruitful parent-and-teacher meeting.

However, only when it is made an integral part of each student's classwork in any particular class can the full potential of the school film be realised. A school film unit should be formed with that end in view.

School Film Unit

Before ways and means of organizing the school's own film unit are considered, the teacher must be confident that he or she is able, potentially at least, to undertake the supervision of the project.

In some cases he will have already had years of experience in the production of home movies. Many other teachers, however, may be eager to carry out the work of organizing such a project, but have never handled a ciné camera or witnessed a film being made. Previous experience, though a distinct advantage, is by no means essential. But a teacher must have a fund of enthusiasm and a readiness to study the subject of cinematography. Later he will have to devote a considerable amount of spare time to the project.

Some previous experience of still photography is sure to help considerably in solving the many problems which are likely to confront the film makers. Matters of composition, exposure, focusing and lighting are common to both still and ciné photography. Happily, a still photographer frequently discovers that a ciné camera poses remarkably few problems that he has not met before. Nevertheless, any teacher who is a newcomer to the absorbing world of ciné photography should make himself thoroughly familiar with general techniques, technical and artistic, while planning the project.

A good way to begin is to study some of the many excellent books and periodicals dealing with various aspects of amateur and professional movie-making. Some of the best of these are listed in the Appendix.

A second good idea is to join a local ciné club. It will be found that members are more than willing to provide the novice with a deluge of advice, much of it really constructive, even though he does not have his own camera or projector. If the ciné club is lively enough to produce its own films, as most of them are, the experience of taking part in a club production will be of great value.

Thirdly, a teacher should make an effort to study carefully any good films which come his way, both amateur and professional. Some towns have film appreciation societies which are well worth joining. It is remarkable how much more absorbing a good cinema film can become if you look at it with a keen eye to the techniques of directing, acting, photography and editing. A ciné club showing of prize-winning amateur films, particularly school films, is worth seeing too. There the beginner can learn how simple and practicable filming methods can be effective, and train his eye to notice faults in film production which can be seen even in some successful efforts.

While accumulating knowledge and experience in these ways, the teacher can take the first steps towards forming the school film unit. He must first decide whether it is feasible to use only school time for the project, or whether to do all the work outside school hours. Very often some of each is the best way.

As already pointed out, students taking an academic course aligned firmly to conventional subjects and examinations cannot spare the time for a film project within the school time-table. In this case the practicable solution could be to form a school ciné club, meeting on one evening in the week and going on location outdoors every Saturday, weather permitting.

Non-academic classes, with the co-operation of a sympathetic and progressive head teacher, can carry out the film project largely in class time, especially when it is planned to cover a great deal of academic work, involving several departments of the school.

18

In the initial stages at least, one class is sufficient to take part, except perhaps for crowd scenes. The class could include both boys and girls. It is my experience that girls derive just as much benefit from a film project as boys, but that the total number is best kept within reasonable proportions. A class of between thirty and forty is not too large, though if a teacher is fortunate enough to have a smaller group, this would be better still.

The question of the suitable age-group cannot be answered with a hard-and-fast rule. I find that a film project suits a third-year class, consisting of pupils about fourteen years of age; but many successful school films have been produced elsewhere by children a good deal younger. Indeed, I have actually seen a first-rate prizewinning film which was made by a class of infants. How much of the actual work of film-making was tackled by these children, however, I cannot say.

Older secondary pupils are doubtless capable of a more skilful and polished piece of work than can be produced by fourteen-year-olds. Nevertheless it is truly astonishing what an excellent film can be made by a group of non-academic boys and girls newly in their teens. A film project would seem eminently suitable for the extra fourth year, after the raising of the leaving age to sixteen.

The aim of the school film unit should be made clear to the boys and girls from the outset. The object is to enable the pupils to make their own films from start to finish, with the absolute minimum of aid from their teacher.

Funds for Equipment

The first essential for the film unit is equipment.

In many cases where a school film unit has been formed, the matter of equipment has not proved much of a problem, because a teacher—or, as in the early days of our own film unit, the school janitor—has ciné equipment which he is willing to make available. This can be a straightforward way out of the difficulty, but it would be better to regard it as a

strictly temporary expedient until ways and means have been devised of acquiring school equipment.

There are many methods of doing this. The hard way, running concerts, sales of work, whist drives, dances and film shows may be chosen. This necessarily involves certain teachers in a great deal of work, and presupposes considerable goodwill among those staff members who help. A number of teachers who favour traditional teaching methods are liable to view the whole project with suspicion or antipathy, and it may be difficult and undesirable to ask for their assistance. Nevertheless, the idea of organizing such a fund-raising effort should not be too hastily discarded. Indeed, it can prove a highly successful method.

Fortunately, help can often be obtained from other quarters. Not everyone has access to wealthy benefactors (though some schools do), but most schools have a school fund, and a grant from this may perhaps be available.

Local education authorities vary to a remarkable extent in their munificence. The apparent parsimony of some may be no fault of their own, but some committees are much more open-handed than others. Some authorities are fortunate enough to have access to a trust fund, with money available to cover this kind of educational expenditure. Others may see fit to supply the entire equipment simply as part of the school's annual requisition. This is naturally a matter for enquiry by the head teacher.

Another scheme is for a small group of schools, say three, to aim at the co-ownership of ciné equipment. But this idea might soon pose more problems than it solved.

It is worthwhile to contact a local ciné dealer who is known to be interested in the school, or sympathetic with modern trends in education, or both. He could prove to be a real friend to the film unit, as happened in our case, giving much valuable advice and assistance; partly, no doubt, in return for the school patronizing his shop, but partly out of sheer goodwill.

20

Equipment for Filming

We must first decide on the size of film to be used. This is chiefly a question of quality, economics and ease of handling.

There are nowadays five alternative types of film available to the amateur in three basic gauges. We must choose from 16 mm., 9.5 mm., regular 8 mm., super 8 and single 8. Others, which include various widescreen systems, cannot be considered as practical propositions for our present purpose.

Without doubt the finest results in amateur film are to be obtained with 16 mm. film stock and equipment. This is the largest gauge in general amateur use. It is also the gauge used in the main by producers of educational and publicity films shown in schools, and the gauge favoured by many competition entrants. It might appear at first that if the school already has a 16 mm. projector for the showing of educational films, as so many have, then it would be logical for a school film unit to be equipped with a 16 mm. ciné camera. Then there would be no need to purchase a new projector.

But there is more to this than meets the eye. The teacher who wants to equip a school film unit should take a long, hard look at first principles before spending any money.

What is the purpose of the filming project? Is the major objective to produce first-rate films for showing on a ten-foot-wide screen to large audiences?

For most schools this is only a vague possibility, although it may seem an attractive and exciting one. The true aim of a film project is simply to provide a centre of interest and give the pupils work to do. Ultimate presentation on a very large screen is certainly not an essential feature of the

project. The screen brilliance and fine picture quality associated with 16 mm. are in themselves not sufficient justification for the formidable financial outlay required.

A good new 16 mm. ciné camera is very much more expensive than a comparable one using a smaller gauge of film. It is also rather heavy and cumbersome. Accessories that go with it, such as supplementary lenses and tripod, are correspondingly expensive in the 16 mm. size.

Certainly a saving could be made by the purchase of second-hand 16 mm. equipment, but most film units will prefer the reliability of a new and up-to-date ciné camera and projector, with the additional safeguard of guarantees.

The cost of 16 mm. film stock, assuming that colour film is used in preference to black and white, is about three times that of 8 mm. This difference soon mounts up if a full-length film, or series of films is planned.

Many people will regard the cost as prohibitive when adding sound to the film. We will discuss this later on. If a sound projector is already part of the school equipment, it will almost certainly be one using an optical sound system. Amateur sound films on 16 mm., on the other hand, normally use the entirely different system of magnetic sound. This necessarily entails the purchase of a new 16 mm. magnetic sound projector (unless a Synchrodek is used, as described later), and the original reason for considering 16 mm. for a school film unit will have disappeared.

Another point worth considering is that there is nowadays not such a startling difference, on a 4-foot-wide screen, between 16 mm. quality and that available to the user of a really up-to-date 8 mm. projector.

Thus, while a number of schools may be in a position to use a 16 mm. ciné camera, most teachers will find that the gauge is uneconomic and over-ambitious for school filming.

Another possibility is 9.5 mm. At one time this was a really popular gauge for amateur film makers. A saving in space on the film, as compared with 16 mm., is achieved by placing perforations, by which the film is moved, in the

22

centre, between frames, instead of the edge. Each frame is smaller than in 16 mm., but film stock does not cost much less. Much 9.5 mm. equipment is comparatively inexpensive, though still rather cumbersome, and second-hand equipment using this gauge can be extremely cheap.

However, 9.5 mm. equipment and film stock is generally rather hard to come by, and the choice is extremely limited. Despite the eager enthusiasm of a handful of devotees, the future of 9.5 mm. is undeniably uncertain.

Standard 8 and Super 8

By far the most popular gauge for many years among amateurs has been 8 mm. This film size was introduced many years ago. It is 16 mm. wide, but not similar to normal 16 mm. film. It has twice as many sprocket holes on each side and can only be used in cameras designed specially for it. Cameras taking this type of film, the correct name of which is double 8 mm., are designed so that when the film is run through the camera, only half the width is exposed. When the 25 ft. length of film has been run through the camera is opened, in subdued light if possible, and the reels are reversed. The camera is then closed again and the film is then exposed down the other side. At the processing station, after development, the film is slit down the centre and the two pieces joined end to end to form one 50 ft. length of 8 mm. film with the sprocket holes down one side. This is returned to the user and is ready for projection.

There are many reasons for the overwhelming popularity of 8 mm. film. Firstly, equipment and film stock are available everywhere and are comparatively inexpensive. The cost, including processing, is about 1d. a second, or 7d. for six seconds, which is the duration of an average action shot.

Further, despite the tiny dimensions of each frame on the film (the projected area, in fact, measures 4.37 mm. by 3.28 mm.), the quality of 8 mm. is now astonishingly good. The enlarged picture has no longer the grainy appearance it used to have, and the image can be projected satis-

factorily, using a good modern projector, on a screen 6 ft. wide or even more. A smaller screen, say 3 ft. wide, perfectly adequate in size for classroom use, gives a picture as bright and sharp as anyone could wish.

As a matter of interest, an extract from "The Miraculous Mandarin", our school's 8 mm. contribution to the Scottish Film Festival, was projected in the Cosmo Cinema, Glasgow, using a medium-priced projector (with a tungsten-halogen lamp) placed at the front of the balcony, so that the image almost filled the 14-foot-wide screen. The quality of the picture was not exactly superlative, but it was really remarkably good. When you consider that this amounted to a magnification of something like 800,000 times, you can realize that quite incredible things are now possible with this gauge.

Thus, until very recently, double 8 mm., also known as regular 8 mm. or standard 8 mm., would have seemed the obvious choice for a school film unit.

The latest innovation, however, has altered the situation drastically. This is the revolutionary super 8, the name given to a new format of film and system of cameras and projectors. This involves the use of film stock 8 mm. wide which only runs through the camera once. It has narrower sprocket holes. These had always been unnecessarily wide on standard 8. This allows space for a 50 per cent larger picture than before (a projector aperture of 5.36 mm. by 4.01 mm.).

There are several clear advantages in the super 8 format. The larger frame size means either a larger screen image or a brighter and sharper one, as required. A comparative side-by-side demonstration of the two formats will show that the superiority of super 8 in definition and illumination is most marked.

With the super 8 mm. size the sprocket holes are placed in a more sensible position, beside the frames instead of at the masked area between them. This makes for stronger splices when you come to the editing stage.

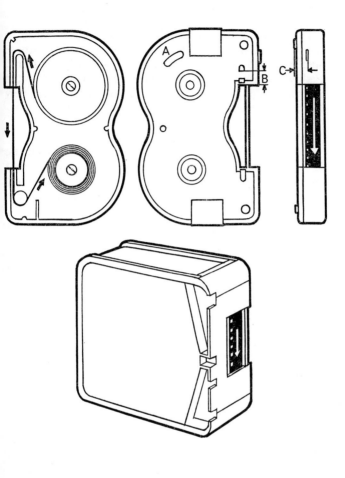

Two kinds of instant loading film magazine. *Top, left:* A view inside the single 8 magazine showing the path of the film. *Top, centre:* An outside face of the magazine showing dimensions of the recesses and spaces which vary with the ASA speed of the film, automatically setting the camera for the correct film speed. *Top, right:* Front view at the start of running the film. *Bottom, left:* Super 8 cassette showing film path and coded slots to set the film speed and position the filter in the camera.

25

The space left at the other side of the film, intended to be used for sound stripe, is a better position for this purpose than beside the sprocket holes, and provides better sound quality for users who choose the stripe method of sound recording. For various other technical reasons the new format provides a steadier picture on the screen.

Instant Loading

To the majority of movie makers, however, these features, desirable though they may be, are not the real attraction of super 8. The vital feature to most people, and an extremely important one as far as a school film unit is concerned, is the camera loading system.

The ever-present bugbear of 8 mm. filming, to the man or woman (not to mention the child) in the street, has always been the tedious procedure of threading each film into the ciné camera, and the further necessity of opening the camera again after two minutes' filming and reversing the two reels. Even the most skilful user of standard 8 has probably had the infuriating experience at one time or another of finding one of his precious shots ruined by edge-fogging, caused by daylight falling on the film while it was being loaded or changed over. Further, it is all too probable, in the nature of things, that a golden eagle perches on a branch at the precise moment when the cameraman finds that he has come to the end of the first or second side of the reel. After turning the reels over, or carefully threading a new film, the frustrated photographer finds that it is too late, and an unforgettable shot remains just an undocumented memory.

This threading business has always amounted to a real deterrent to many potential film makers who had little interest in the inner workings of a ciné camera, and merely wished to make films in the simplest possible way. Indeed, many skilled users of standard 8 find the same thing.

There have certainly been many attempts by manufacturers of standard 8 ciné cameras to provide easier and safer loading, generally either by the use of a magazine or

26

by an automatic threading device. These methods have never achieved really widespread popularity, no doubt owing partly to the high cost of these special cameras and their magazines, and partly to the need of loading magazines with film beforehand.

The super 8 system has been designed for use with a new breed of ciné cameras incorporating a really smart and ingenious cassette loading system. Each film is in single-run form, and is supplied in a neat, robust cassette which also contains the take-up spool. It is only necessary to open the camera, place the cassette inside, close the camera and start filming. There is no possibility of fogged film, no need to stop filming after two minutes or so and turn the reels over, no reason for having unexposed or double-exposed film, and no chance of losing precious shots owing to the time taken in re-loading.

There are still further advantages in super 8 to be taken into consideration. But consider first a characteristic of all colour photography. The difference in colour quality between daylight and artificial light has a greatly exaggerated effect on colour film. Any film must be made with a bias to either one or the other. Super 8 colour film is suitable for use in indoor artificial lighting; that is, it has a slightly cold colour bias to cancel out the redness of photoflood lamps. If shots are to be taken outdoors, a warm-coloured conversion filter incorporated in the camera covers the lens, correcting the colour balance. For indoor conditions, either a lamp-holder or a metal or plastic key is fitted into a slot in the camera, with the immediate result that the conversion filter moves aside from the lens.

When it is inserted into the camera, each cassette also automatically selects the correct adjustment for the particular speed of film contained in it. With standard 8 cameras this has to be manually set by the user.

In a series of tests undertaken in our school, using a standard 8 camera and an inexpensive super 8 camera, it was found that it took $2\frac{1}{2}$ minutes for the most intelligent

27

pupil, after careful guidance, to load our standard 8 camera with film. The same pupil, after one brief demonstration, loaded the super 8 model easily in three seconds. Every other pupil in the class, including the dullest, took no more than four seconds.

This new system has now been taken up by the majority of camera manufacturers.

There are two disadvantages in choosing super 8, however.

Cost and Usefulness

One is its greater cost than standard 8, at least at the present time. Whereas standard 8, as we have seen, costs about 1d. for a second's filming, or 7d. for a shot lasting six seconds, super 8 costs about $1\frac{1}{2}$d. a second, or 9d. for six seconds. This higher cost can be attributed to the fact that you have to buy a new cassette with each film. But, as there is no chance of fogging or otherwise wasting the new film, super 8 might in fact turn out, for many people, to be no dearer than standard 8.

The other disadvantage about super 8 is that with the present design of its cassette, it cannot be back-wound or re-used in the ciné camera. This precludes the possibility of certain double-exposure effects. This disadvantage may be regarded by advanced workers as a serious one, although those who make use of double-exposure techniques in 8 mm. filming are in a very small minority.

One more factor which should be borne in mind is that prices of new and second-hand standard 8 equipment have fallen, some of them dramatically, since the introduction of super 8. It is also likely that film stock and accessories for standard 8 will continue to be available for as long as the public desires, which will probably be for a very long time. It is not everyone who can afford to write off, or sell for a song, his standard 8 ciné camera, projector, splicer and editor, and purchase a brand-new super 8 outfit.

However, anyone deciding on the purchase of equipment for a new school film unit is in a very different position, and

will probably decide that the advantages of super 8 far outweigh its disadvantages.

The ambitious school film producer may regret that he cannot film transparent ghosts, twins portrayed by one actor, or superimposed titles, by means of double-exposure techniques (as described in a later chapter for the benefit of those who own standard 8 equipment). These effects can be difficult and complicated anyway. Besides, a superimposed title with a moving background can, if required, be achieved by methods other than double exposure.

The most significant factor, and in my opinion a decisive one, is that it is much more important, for the purposes of a filming project, that ordinary pupils should be able to operate the ciné camera unaided, than that a few ambitious special effects should be possible.

A rival to super 8 has also appeared on the market—the Japanese single 8 system. This uses film stock of exactly similar format to super 8, but made of polyester base material, which is thinner but very strong. Daylight-loading, single-run cassettes are used, but with the difference that the two spools inside are positioned one above the other instead of side by side.

The main advantage of the single 8 system over super 8 is that back-wind is possible, although many of the simpler single 8 ciné cameras have not this facility. Film stock for this system is of good quality but is of only one make. Splices must be made with adhesive tape and not cement. There is no doubt that the single 8 cassette system works excellently.

I would suggest finally that any teacher or youth leader who is in doubt about the relative merits of standard 8, super 8 and single 8, for the use of children, should, after considering the various points dealt with in this chapter, consult his dealer. He should ask to be shown examples of each type of camera, and a demonstration on comparable projectors using both formats.

COMPARATIVE TABLE OF FILM GAUGES

Features	16 mm.	9.5 mm.	Standard 8	Super 8	Single 8
Cost of new equipment	1 High	2 Medium	3 Low	3 Low	3 Low
Cost of film stock	1 High	2 Medium	3 Low	2 Fairly low	2 Fairly low
Cost of sound stripe equipment	1 High	1 High	2 Medium	2 Medium	2 Medium
Trade-in value of equipment	2 Medium	1 Low	1 Low	3 High	3 High
Availability of equipment	2 Good	1 Poor	2 Good	3 Excellent	2 Good
Availability of film stock	3 Plentiful	1 Scarce	3 Plentiful	3 Plentiful	2 Good
Choice of equipment	1 Limited	1 Limited	2 Reasonable	3 Wide	1 Limited
Future prospects of gauge	2 Good	1 Doubtful	1 Doubtful	3 Excellent	2 Good

Features	16 mm.	9.5 mm.	Standard 8	Super 8	Single 8
Quality of 6-foot-wide picture	3 Excellent	3 Excellent	1 Fair	2 Moderate	2 Moderate
Quality of 4-foot-wide picture	3 Excellent	3 Excellent	2 Very good	3 Excellent	3 Excellent
Portability of equipment	1 Cumbersome	2 Heavy	3 Light	3 Light	3 Light
Ease of camera operation	1 Fair	1 Fair	1 Fair	3 Excellent	3 Excellent
Safeguards against film wastage	2 Various	2 Various	1 Generally poor	3 Excellent	3 Excellent
Suitability for unaided children	1 Fair	1 Fair	1 Fair	3 Excellent	3 Excellent
Versatility for trick shots	3 Excellent	3 Excellent	2 Good	1 Fair	1 Fair
Totals	27	25	28	40	35

Note: The table is an attempt at a fair assessment from the point of view of a person choosing equipment for a school film unit, although values attached to each gauge are purely the author's opinion. A very different set of totals could no doubt be obtained by omission of some of the features and qualities considered or inclusion of others.

Ciné Cameras

Ciné cameras can be found in a great profusion of shapes and styles, and to sell at a remarkable variety of prices, from under £14 to over £320.

The first task of the producer of a school film unit, once he has decided on the gauge of film, is to determine which features and facilities he considers essential for the school ciné camera. He must then, from the variety of ciné cameras available, select the least expensive model which incorporates all those minimum desirable features, and is at the same time reliable, efficient and easy to operate.

The ciné camera is simply a device for exposing a series of tiny photographs in rapid succession on the sensitized film. These "frames" are exposed at a standard speed of 16 or 18 per second. The 16 frames per second speed is the one widely adopted for standard 8 cameras. Super 8 cameras use the 18 f.p.s. standard. People using the magnetic stripe sound system (see p. 52) often take films at 24 f.p.s., which is an alternative speed available on some cameras, though with super 8 equipment the 18 f.p.s. speed is suitable for sound purposes.

Many ciné cameras are designed to operate at several additional speeds, from 8 to 64 f.p.s. The slower the running speed of the film in the camera, the faster the action appears on the screen; and vice versa. Both fast and slow motion have their place in amateur films, and this matter is discussed further on page 75. It is certainly convenient to have the facility, in case of the odd comedy or dream sequence.

However, most amateur and professional films are made without the use of fast or slow motion, and the facility cannot be regarded as essential for our purposes.

Many cameras are designed so that, if necessary, one frame may be exposed at a time. This feature is much more important, and will be invaluable to those many film units which will attempt some animated work at a later date, in titling, live action or cartooning.

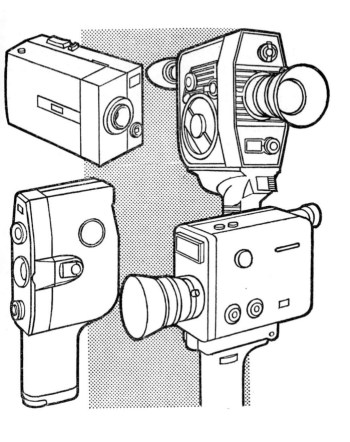

Four camera models. *Top, left:* A simple super 8 camera with manual exposure control and optical viewfinder. *Top, right:* Standard 8 camera with optional auto/manual exposure control, and reflex viewfinder. *Bottom, left:* Single 8 camera with automatic exposure control (not manual) and optical viewfinder. *Bottom, right:* Super 8 camera with auto/manual exposure control and reflex viewfinder.

33

Focus and Exposure

An inexpensive ciné camera is usually fitted with a fixed-focus lens—a lens permanently set so that any subject at a distance beyond 10 to 15 feet will appear sharp on the film. This type of lens is perfectly satisfactory for most well-lit scenes, but for close-ups a supplementary close-up lens must be fitted over the camera lens. This is not expensive.

Lenses on more expensive cameras are of the focusing type, so that nearby subjects can be rendered sharp on the film without the use of a supplementary lens. The nearer the subject is, the more necessary it is to focus accurately. To measure the distance, a rangefinder or focusing screen can be used, or incorporated in a camera, but for the short distances involved, a tape measure is almost as convenient and very much cheaper.

The amount of light entering the lens is controlled, as in the human eye, by an iris diaphragm. On a bright day this opening can be reduced in size, and in dull conditions opened wider. The diaphragm control is calibrated in a series of f-stops. It is worth noting that the wider the aperture, that is, the duller the scene, the more accurate the focusing must be, particularly with nearby subjects. The lens is described by its maximum aperture, say f 1.8, which is a relative measurement and need not concern us at this stage.

On cheaper cameras, adjustment of the iris is made simply by a hand setting, based on tables or symbols, and sometimes this is not a very accurate method.

A more satisfactory system involves the use of a photo-electric exposure meter which, being sensitive to light, can judge the brightness of the scene and indicate correct exposure. The meter is either the selenium or the cadmium sulphide type—the latter, which requires a battery, being the more sensitive of the two and having several other slight advantages. Some ciné cameras have a semi-automatic meter built in, so that, by pointing the camera at the subject and aligning two needles the user sets the aperture to the

appropriate stop without needing to consult tables or a separate meter.

Most ciné cameras nowadays are fitted with a meter which is completely automatic. With this system, the light falling on the meter actuates a mechanism which moves the iris diaphragm to the correct aperture, and the question of setting the exposure does not arise for the cameraman.

It is, however, an advantage if an automatic camera of this type is designed so that the photographer can, if he wishes, manually alter by a stop or two the aperture which has been selected by the automatic meter. This might be necessary in order to achieve special lighting effects, to film against the light, or to change the exposure to favour a shadowy subject which is in a bright scene.

When the motor speed is set at a low number of frames per second, each frame is exposed for a longer time than normally. This can be used in an emergency to film in very poor lighting conditions.

With colour film over-exposure results in a pale, washed-out image, while an under-exposed scene looks dark and gloomy. Colour is used by the vast majority of amateurs, and will no doubt be used by the school film unit.

The motor of a ciné camera can be clockwork or electric. A good clockwork one will reach its optimum speed immediately, and thus does not over-expose the first frame of each shot. This "flash" frame can all but spoil a trick effect.

An electric motor, of course, dispenses with the troubles of winding, and enables scenes of long duration to be filmed. The great majority of super 8 cameras are battery-operated. The only necessity with an electric camera is to be sure to have spare batteries, especially if the ones being used are getting low. Some cameras have a very useful device to indicate the state of the batteries.

Kinds of Lens

The simplest type of ciné camera has a single lens of fixed focal length, giving a picture which includes enough

35

of a scene to be satisfactory for most purposes. There are, however, occasions when the cinematographer would like to concentrate his audience's attention on a distant object or a small part of the general scene; for example, a person up on the ramparts of a castle, seen from below. Alternatively, it might be necessary for the camera to take in a wider view than would normally be possible; for instance, a general view of a classroom.

The altered angle of view involved in these two examples, and in many more that could come to mind, can be achieved on some cameras by removing the lens and substituting a long-focus (telephoto) or short-focus (wide-angle) one. This has often been simplified by two or three lenses being fitted to a revolving turret on some cameras.

A long-focus lens has the effect of foreshortening a scene. It can make a crowded playground seem even more full of children than it is. A short-focus lens, on the other hand, makes distant objects seem still further away and exaggerates the scale of nearby objects. This can make a chase sequence moving towards or away from the camera seem more exciting, as the advancing person grows more rapidly in size, and appears to be moving faster.

A large number of modern ciné cameras are fitted with a zoom lens, which provides an infinite variety of focal lengths on one lens. This is a more convenient device than the turret, and enables the cameraman to fill the frame with his subject in a most satisfactory way. If a zoom type camera is chosen for the unit, care must be taken to select one with a lens of good quality. A cheap zoom lens gives poorer pictures than a simple lens of fixed focal length.

Most audiences are only too well aware of the spectacular potentialities of the zoom lens. The effect of being rapidly zoomed into or out of a scene can be disconcerting or even sickening if done too frequently. No audience deserves the results of rapid zooming combined with unsteady panning.

Thus, like many other modern marvels, the zoom lens must be used gently and with discretion. Many experienced

36

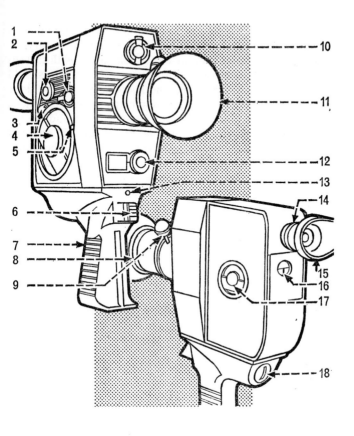

Features of a ciné camera. 1, variable shutter control; 2, filming speed control; 3, socket for rewind crank; 4, motor (clockwork) winding key; 5, release selector; 6, release; 7, grip; 8, focusing ring; 9, zoom lever; 10, auto/manual control knob; 11, lens hood; 12, film speed setting knob; 13, cable release socket; 14, adjustable eyepiece; 15, rubber eyecup; 16, film footage counter; 17, latch for side cover; 18, compartment for meter batteries.

cinematographers make it a rule to film while zooming to a different focal length only where strictly necessary. A zoom shot, if it is taken at all, should begin with a well-composed scene and end with another. The camera should be set on a firm tripod and the zooming should be done very smoothly. Here a power zoom helps to give steadiness.

On the whole, it is certainly a benefit to have additional lenses or a zoom lens, but it should not be thought essential for a school film unit. It adds considerably to the initial cost, especially if the zoom lens is of high quality and has a wide range. Many highly successful amateur films have been made using a camera with a simple lens of fixed focal length.

Other Features

A viewfinder of the reflex type, where you actually see through the lens that takes the picture, avoids the common fault of cutting off heads, and makes close-up filming and the filming of titles comparatively trouble-free. The matter is discussed with titling on page 85, where a device is described which can easily be constructed to avoid the difficulty when using a camera which has a viewfinder separate from the lens.

There are many other refinements in ciné camera design which are available to the ambitious, the expert or the affluent. These include back-wind (but not with super 8); a variable shutter, to enable the user to produce fades and dissolves, which admittedly seem to be out of fashion nowadays; remote control, for starting and stopping the camera from a distance; macro lenses, to make films of tiny objects, a useful feature for science lessons; and so on. Few, however, would insist that any of these features are essential in order to make good school films.

Briefly then, the choice of a camera depends on finance, and also on how ambitious the school film unit will be.

The finest 16 mm. cameras are those used by professionals, and are certainly beyond the scope of this book. As there is

now very little demand among amateurs for new but inexpensive 16 mm. equipment, the selection is very limited.

There is even less choice of 9.5 mm. equipment. The leading country of manufacture is France, where this gauge is better established.

With 8 mm., the story is very different. The annual movie camera guides published in ciné periodicals generally list over 100 models available in Britain; and these can also be seen in various dealers' catalogues. Most of the twenty or so leading firms in the U.S.A., Japan, Austria, Germany and Switzerland produce both standard 8 and super 8 models.

The prospective purchaser should be warned to avoid super-bargains in new 8 mm. equipment. It would be far more satisfactory for a school film unit to select, for instance, a simple ciné camera with a single fixed lens and very few special facilities, than to fall for an "incredible bargain" at under £25 incorporating power zoom, reflex viewfinder, and other features normally found only on more expensive equipment. It is just not possible to produce a really worthwhile ciné camera with those features at anything like this price.

Among the most popular 8 mm. models are several which are recommendable and extremely cheap. They have a simple fixed-focus lens and no special features such as single-frame facility, reflex viewing, manual override or zoom lens. The simpler and cheaper type of zoom camera has a fixed-focus lens and separate viewfinder.

The school film unit producer who wants a reliable camera with a reflex viewfinder and a choice of focal lengths will have to face inevitably higher cost. However, this may prove worthwhile, especially if a good-quality zoom camera can be found which also incorporates the single-frame facility.

Features of 8 mm. Cameras and their Value

If standard 8 equipment is to be used, this should include an "A to D" conversion filter, which is already fitted to super 8 cameras. It enables the camera team to utilize artificial-light colour film all the time, by placing the conversion filter in front of the lens for shots taken in daylight. By this method, indoor and outdoor shots may be alternated freely on the same roll of film, to suit prevailing weather and time-table conditions. Many experienced users actually prefer the colour rendering thus obtained in daylight to that of ordinary daylight film.

	Essential	Valuable	Worth having	Unnecessary
Robust construction	★			
Simple operation	★			
Electric motor			★	
Choice of filming speeds			★	
Battery condition indicator			★	
Single frame release		★		
Focusing lens				★
Reflex viewfinder		★		
Rangefinder				★
Exposure meter, fitted or separate	★			
Automatic exposure control		★		
Manual override			★	
Wide maximum aperture			★	
Alternative focal lengths		★		
Fitting for cable release		★		
Automatic or cartridge loading		★		
Back-wind				★
Facility for double exposure			★	
Variable shutter				★
Remote control				★

The alternative, with film stock other than super 8, might be to use daylight film with a "D to A" conversion filter for artificial lighting conditions. This, however, is not generally recommended, as the colour balance is somewhat inferior. Moreover, as daylight film is not so fast as artificial-light film, fitting a conversion filter makes daylight stock even

slower, and this means that you need lighting that would be exceptionally bright.

A haze or ultra-violet filter is sometimes used by people filming in the mountains or at sea. It cuts down slightly the bluish colour of these scenes.

A tripod, and a really sturdy one at that, is essential practically all the time. The tripod should have a smoothly-operating pan and tilt head. It is not worthwhile buying a cheap and flimsy tripod. Stability is much more important than portability. There are many different models of good quality on the market, costing from £5 upwards. A feature worth having on the tripod is an adjustable centre column, which can be most useful when filming titles on the floor from above.

A unipod or chain-pod (or perhaps simply a looped piece of cord attached to a tripod screw and held by the foot) can be a reasonable substitute, if the film unit is in a location, perhaps abroad, where it is not convenient to carry a tripod.

For shots where no camera movement is involved and the camera is on a tripod, it is much less likely to be jolted while the film is being taken if you use a cable release. If there is no locking device on the camera to enable the motor to run continuously without attention, this can be achieved by purchasing a cable release with a screw for the purpose.

If you have to take hand-held shots it is much easier to hold a camera steady in the hand when you use a pistol grip. This can be attached to the base of the camera, but you should try it on your model before purchasing. A camera support such as a tripod is certainly preferable, if it is available.

A lens brush is an essential, but, surprisingly enough, it is not nearly so frequently used for cleaning lenses—which are delicate and must not be scratched—as for cleaning the inside of the ciné camera and the gate of the projector, and for dusting the top of a splicer. A particularly useful type has a rubber bulb for blowing away dust or hair.

Lastly, the ciné camera should have the protection of a case; and it is very convenient if this is the "holdall" type, large enough to contain any accessories and a couple of rolls or cassettes of film.

Choice of Lighting

Lighting equipment will certainly be needed. A large number of amateurs make use of a "bar-light", usually incorporating two photofloods with integral reflectors, and attached by a bar to the ciné camera itself. This has the virtue of simplicity, and could indeed prove very convenient when the film unit is taking "newsreel shots". The reflector photofloods consume only 375 watts each, but two will provide a large amount of illumination. They are not very costly.

Note that bar lamps beside the camera give only basic flat lighting and the background will not be adequately lit unless the subject is close to it. This is particularly important if a camera with fully automatic exposure control is used, as the camera's exposure meter takes a general reading from the whole scene, including the background. If the foreground is much more brightly lit than the background, as might happen if a barlight attached to the camera is being used to film children at a party in a large hall, the comparatively dark background will influence the meter into over-exposing the foreground figures. This can only be allowed for if the camera has either a semi-automatic exposure system or a completely automatic system with manual override.

A good alternative, or addition, to the photoflood bar system of lighting is to use three or four cheap reflectors. The clip-on type are very convenient. These hold ordinary photoflood lamps. The 500 watt No. 2 type is suitable. With these lamps, the whole scene can generally be illuminated quite satisfactorily, and extra photofloods can be plugged into the main overhead lamp sockets of the room to provide fill-in light. Ambitious film units may aspire further to the

42

exciting paraphernalia, cumbersome but very efficient, of full-size booms and stands.

A type of ciné lighting that has appeared in recent years is the tungsten-halogen lamp, also known as quartz-iodine. This is usually fitted to a holder called a Sun Gun, which can be attached to the camera. The lamp has an output of about 1,000 watts. Although the lamp is comparatively expensive it lasts about 15 hours, and if a surge-resistor is incorporated, its life can be trebled. The light is exceedingly brilliant, though not unduly dazzling, and the effect is highly satisfactory.

Even more effective is the tungsten-halogen unit which has two lamps, each of about 625 watts, which can swivel independently up and down. Thus one lamp can illuminate the main subject while the other "bounces" light for the whole scene from the ceiling. The device can be hand-held, attached to the camera, or fixed to a tripod.

Equipment for Editing and Showing

Some equipment is required for the later stages of making a film, when it is edited, cut, and the various scenes sorted and joined together. While doing this you need something to view the raw material and the results, so it is not really practicable to make a film without an editor-viewer. When the film has been processed and returned this device will show the moving film on a small back-projection ground-glass screen. The reel can be wound backwards or forwards at will. The person doing the editing views and cuts the film as he wishes and rearranges the shots easily. Some people attempt to use a projector for this purpose, but it is a heavy-handed method, and is hard on both film and projector bulb.

There are many excellent editor-viewers on the market, ranging in price from about £7 to £45. But remember that a standard 8 editor will not take super 8 film, nor vice-versa. Some of the cheaper models will give very good service. At a slightly higher price there is usually the benefit of geared rewind arms which make it quicker to handle the film, and a larger and brighter screen.

Some editors are more suited to anti-clockwise unwinding of the left-hand spool than to the more general clockwise rotation. It is as well to select an editor which operates in a similar way to the film unit's projector.

It must now be decided what kind of splicer is to be bought. The cheaper kind which uses adhesive tape is rapid and easy to use. But for really neat, almost invisible and permanent joins, the cement type is superior. The best kind

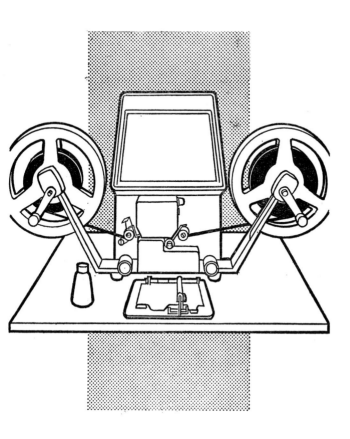

An editor-viewer. Film passes from one geared rewinder to the other via the viewer. A lamp and rotating prism optical system throws an image of each frame on to the screen as film is wound through. Film may be freely moved in either direction. On the front of the board is a splicer and to the left a bottle of film cement.

is that which tapers both film ends, making a smooth bevelled joint.

The results after using a bevel splicer are first-rate. The splices are confined practically to the frame-line, that is, between the pictures rather than across them. They do not increase the thickness of the film to any appreciable extent and so avoid the annoying clicks and jumps associated with conventional overlap splices. The welded joints, if properly cemented, should withstand any strain.

An ingenious innovation is the splicer which cuts matching serrated edges on the two pieces of film, making a very strong butt-type cement splice. Another new splicer incorporates motorized scraping, and this produces a really first-class and almost invisible bevel joint.

It will be found that a twelve-year-old boy or girl is perfectly capable of making good splices. Again, the appropriate type of splicer must be chosen, standard 8 or super 8. Some take either gauge.

Your local dealer will be able to advise which is a suitable type of cement to use. It is better to buy only one bottle at a time, and not to continue using it for more than a month or two as it deteriorates fairly rapidly.

Projectors

Outwardly there often seems to be remarkably little difference between one make of projector and another, as far as method of operation and incorporated facilities are concerned. Differences, however, soon become apparent when various projectors are actually tested in operation. Here price is very often a reliable guide to quality.

The chosen projector should be able to take a 400-ft. reel, and it would be as well to purchase a spare reel. It is also advisable to have a spare projector bulb.

The most important points for a projector are steadiness of picture, efficiency of lens, and brightness of image. It is strongly recommended that the film unit's producer should examine several models before making a choice.

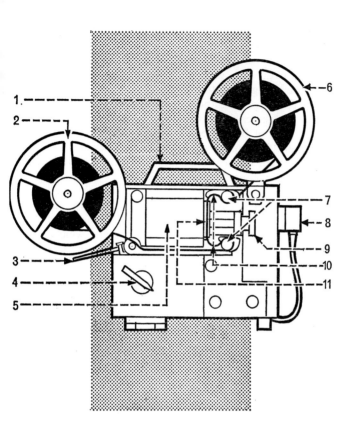

Main features of a film projector. 1, carrying handle; 2, take-up spool;
3, take-up film guide; 4, operating switch; 5, lamphouse; 6, feed spool;
7, drive sprockets; 8, mains input; 9, lens; 10, loops of film above and
below gate; 11, film gate.

Picture steadiness depends partly on the design of the claw which rapidly pulls down the film frame by frame, and partly on the general standard of workmanship, particularly of film path and gate. In lower-priced models a small-aperture lens gives better results.

Screen image brightness depends partly on the aperture, partly on the design of the optical system, and partly on the actual type of bulb used. Tungsten-halogen lamps are increasingly favoured for projectors, as they are somewhat brighter than conventional bulbs, last longer, and do not become discoloured with age. Adaptors are available to convert some makes of projector to take such a lamp.

The favourite selling points in projectors are really less important than the three features already mentioned. Most modern machines are fitted with a zoom lens, which enables the user to adjust the size of the picture to the size of the screen without moving the projector. However, if a non-zoom lens is an available alternative, it is likely to give a slightly sharper and brighter picture. A zoom lens should be tested at all settings before the projector is bought.

Automatic threading, right on to the take-up reel, is rapidly becoming a universal feature. For the average enthusiast, this is merely a fascinating but unnecessary gimmick, and can indeed lead to difficulties if the threading cannot alternatively be done by hand. However, with a school film unit, this feature becomes much more significant. It is an excellent thing if exhibiting the film can be entrusted to pupils as part of the project. It can certainly be achieved if the projector has a foolproof automatic threading system. Many people find that forming the necessary loops is the tricky part of threading up a projector.

In one popular type, the end of the film is pushed into a slot, and the top of the loop-former is depressed with the finger. The motor is switched on, and the film begins to move, forming the correct loops. Then the loop-former is released, and the film glides on along its path until it reaches the take-up spool. There it attaches itself neatly to tiny

hooks on the core of the spool, and the film begins showing.

Most projectors have facilities for reverse action, slow motion and showing a still picture. None of these is essential, although reverse action will be necessary if the projector is being used temporarily as an editor-viewer. The still picture is always rather dim, as it is projected through a heat-resisting material

In the standard 8 range, there is a wide choice of first-class projectors able to show 400-ft. reels, with some machines at very reasonable prices. Some firms manufacture super 8 adaptations of these projectors, but in many cases makers have taken advantage of the new gauge, as with their cameras, to design new models completely from scratch.

Several manufacturers have given the matter of projecting super 8 and standard 8 films considerable thought, and have designed projectors which may be used with both gauges. In one example, there is an ingenious arrangement for change of gauge, operated by pushing the appropriate button. Any pupil should be able to operate this after a few minutes' instruction.

The dual-gauge projectors are somewhat more expensive than their super 8 counterparts. But they fulfil a real need. Many newly-formed school film units will doubtless opt for super 8, but have access to standard 8 films as well. Clearly a dual-gauge projector is there the ideal solution.

Plan for Sound

Although the notion of adding sound to school films may seem at the outset to be far too ambitious, it is really as well to plan equipment for the film unit with this in mind. Our first school fiction film was made as an unpretentious silent production, but after the final editing it was realized that the film would benefit greatly by the addition of a simple narrative, some background music and one or two sound effects. For this we made use of the tape synchronizing device fitted to the projector.

There are several ways of adding sound to a silent film.

One is to record the sound separately on a tape recorder while the film is showing, in the forlorn hope that every time both are run together, all the sounds will come in at the appropriate moment. This just does not work.

The practical way is to use one of the methods available which automatically keep the machines in step throughout the showing of the film. These methods will be explained in detail in a later chapter, but at present we must examine the problem of sound in so far as it affects the choice of a projector.

Several manufacturers have designed projectors fitted with a loop synchronizer, or have supplied the latter separately, and this highly ingenious system has a number of distinct advantages which make it the choice of a large number of enthusiasts. Briefly, the tape on a tape recorder is looped around a system of rollers and a rheostat pendulum on the projector or on the synchronizer, so that, if both machines are started together, there is no chance of one machine running ahead of the other. In other words, the tape recorder controls the speed of the projector firmly and constantly each time the film is shown.

It has been found in practice that the loop synchronizer system is remarkably accurate and consistent, always provided that the same projector (though not necessarily the same tape recorder) is used for the same film. Several firms have made highly successful machines of this type. One firm supplies a club roller, which can be sent along with film and tape if the film is to be shown with sound on a different projector of the same make. This ensures that synchronization is not lost through variations in the diameter of the respective rollers.

An excellent alternative, highly recommended by many experts, is to use an ordinary silent projector linked to a tape recorder by means of the device known as the Synchrodek. This appliance is connected to the projector by a flexible shaft. It can be supplied with a sprocketed capstan, as can some of the loop synchronizers, so that if perforated

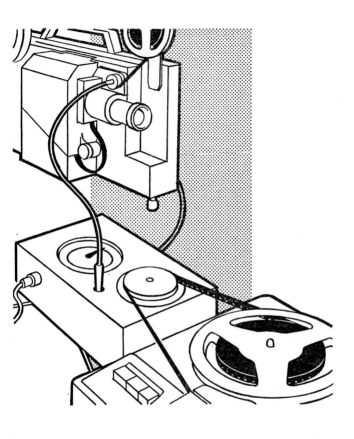

Synchronization of a tape recorder and projector. The synchronizer is connected by a flexible shaft to the projector drive sprocket. Perforated tape is used on the tape recorder and this passes around the capstan on the synchronizer. The tape recorder controls the speed of the projector with a rheostat.

tape is used instead of the usual kind, it is absolutely impossible to lose precise "lip synchronization" even if the film is really lengthy. With this equipment, there is no need to fear that through time the tape might stretch or slip.

An altogether different method is used by the Carol Cinesound system. This does not involve any physical connection between the magnetic tape and the synchronizer or the projector. Instead, it depends on regular electrical impulses obtained from the flicker of the projector's light beam, using a miniature photo-transistor housed in a lens hood fitting. Adoption of the system would involve some modification in the wiring of the projector. The 4-track tape recorder being used must also be modified, and this will alter the working of the recorder, so that it becomes for normal purposes a 2-track machine. However, the system works well, and is worth considering.

Another system is the Filmin Syncronette. With this the ciné camera is coupled to a tape recorder. Exact lip-synchronization is achieved at the moment of filming and the recorded sound remains in exact synchronization during projection.

The chief advantage of all these methods of synchronization, besides the important one of cheapness, is that the sound quality, given a good tape recorder and loudspeaker, is absolutely first-rate. The setting up of tape recorder and synchronizer requires a little patience, but I have found most thirteen-year-old pupils perfectly capable of it.

Sound Projectors

The trend nowadays is towards the stripe projector. The advantages of this system are very obvious. The magnetic sound track, instead of being on a separate tape, is on the film itself. In fact, the projector incorporates its own tape recorder. There are naturally no synchronization problems once the sound has been recorded on the striped film. The finished film can be shown on any stripe projector, and if the film has to be cut, the sound track is cut at the same time. A

stripe projector is also less cumbersome than a separate tape synchronization system.

However, sound stripe projectors of high quality are expensive, and there is also the cost of striping the film. Shooting a film at 24 frames per second, in order to improve sound quality, also adds to the expense. Even the dearest stripe projector cannot produce better quality sound than a medium-priced tape recorder. With a stripe projector it is advisable to have a tape recorder and a Synchrodek too, for a really effective sound track has to be built up on a separate tape before it is transferred to the striped film. All this is dealt with in more detail in a later chapter.

It will be realized that the choice of a sound system depends on a number of factors—cost, sound quality and convenience in the main. It is all very much a matter of personal opinion, and can be further discussed with the local dealer and at the ciné club.

A screen can be a surprisingly expensive item. If there is not one already in the school, the technical department can quickly and cheaply give a 6 ft. by $4\frac{1}{2}$ ft. piece of hardboard a few coats of matt white paint. This will give quite acceptable results.

More and more schools are being issued with tape recorders, which are nowadays regarded as extremely useful teaching aids. If sound films are to be made, a tape recorder of good quality must be either borrowed or bought. Fortunately, many authorities are willing to provide this item on requisition. The recorder should have an output of 2 watts at least, but 4 watts would be more satisfactory, especially for performances in the school hall. Also, there are definite advantages in having a modern 4-track model with provision for parallel playing.

Some manufacturers supply an extra pre-amplifier, either separately or as part of a tape recorder. The purpose of this is to make possible the ingenious systems known as duoplay and multiplay. These too, will be discussed later, but here can briefly be described as methods of listening to one

SOME POSSIBLE CINÉ OUTFITS

(a) *Standard 8: Outfit I*	£	s.
Fixed lens camera	20	0
Cable release		9
Close-up lens	1	10
A to D filter		10
Tripod	6	0
Lens brush		7
Case	4	0
Lighting reflectors (2)	1	10
No. 2 Photofloods (4)	1	10
Editor	10	0
Splicer and cement	4	0
Projector and synchronizer	50	0
Spare reel		8
Spare bulb	2	0
	£102	4

(b) *Standard 8: Outfit II*	£	s.
Zoom lens camera	57	0
Cable release		9
A to D filter		10
Tripod	9	0
Lens brush		7
Case	7	0
Sun Gun	16	0
Spare QI bulb	4	10
Editor	10	0
Splicer and cement	8	10
Projector	60	0
Synchrodek	22	0
Spare reel		8
Spare bulb	2	0
	£197	14

(c) *Super 8: Outfit I*	£	s.
Fixed lens camera	32	0
Tripod	6	0
Close-up lens	2	10
Lens brush		7
Case	4	0
Lighting reflectors (2)	1	10
No. 2 Photofloods (4)	1	10
Editor	10	0
Splicer and cement	4	0
Projector	50	0
Synchrodek	22	0
Spare reel		8
Spare bulb	2	0
	£136	5

(d) *Super 8: Outfit II*	£	s.
Zoom lens camera	50	0
Cable release		9
Close-up lens	2	10
Tripod	9	0
Lens brush		7
Case	8	0
Sun gun	16	0
Spare QI lamp	4	10
Editor	10	0
Splicer and cement	8	10
Projector	50	0
Synchrodek	22	0
Spare reel		8
Spare bulb	2	0
	£183	14

Notes: All prices are approximate.
Not included: tape recorder, record-player, loudspeaker, screen, film stock, tape.
An outfit including a stripe projector would cost about £40 to £80 more.

recorded track while simultaneously recording another, either on to a separate track (duoplay) or on to the same track (multiplay).

A good record-player will also be required for the musical part of a sound track, and it should not be difficult to obtain one for a few days in the event of there being none in the school. Needless to say, a high-fidelity transcription record-player will give better results than an ordinary portable model.

A sound film requires a loudspeaker, and an effort should be made eventually to obtain one capable of reproducing good quality sound. This is not a particularly expensive item. It might be worth constructing, in the technical department of the school, one of the first-rate high-fidelity loudspeaker enclosures available for about £12 as kits from firms advertising in gramophone and radio magazines. However, money can be saved for the time being by making use of one of the loudspeakers used for school broadcasts.

Lastly, a good-quality stop-clock with a quick-return hand is almost an essential for sound recording. Failing that, a stop-watch is the best alternative. A wrist-watch with a sweep second hand may serve, *pro tem.*

Planning a Fiction Film

It should first be made clear to the class involved in the film unit project that a good deal of hard work in the English department must be done before there is any thought of going off on location.

Certainly there is no harm in whetting the pupils' appetite by showing them how to work the ciné camera. They would undoubtedly benefit by using one reel in filming each other acting little outdoor scenes. The resulting shots, lasting up to four minutes in all, might give them an idea of their capabilities and of some of the problems involved in acting for the screen. But most of their real experience will come with the making of the film itself.

The film unit will quite probably make their first effort a fiction film. Indeed, this is the type of film which is most likely to keep every member of the class busy, and to involve work for them all in most of the departments of the school.

A suitable time to start might be about the month of February. This means that the preliminary study and writing can be completed by Easter, so that the first external scenes can be filmed immediately after the Easter holidays. The aim will doubtless be to make one major film each year.

Every class has had plenty of practice in the writing of stories. Now, probably for the first time, this popular type of composition will be put to really practical use.

The teacher can begin by explaining to the class what is wanted—a short story involving all the pupils, some of the members of the school staff if necessary, and perhaps one or two local characters. The locations are to be in and around the school, but pupils' homes and gardens are not

56

excluded, and fictitious locations can later be fabricated on the school hall stage if there is one, or in some available room.

There will have to be a few prominent characters, preferably both boys and girls, upon whom the story is concentrated. The place of hero and villain in a story should now be explained to the students and discussed. The pupils could also consider the possibility of bringing in a touch of the supernatural.

The story can be humorous or thrilling, or a combination of both. The value of suspense and the function of a story's climax can be explained, and examples given to the class. Lastly, the story must above all be practicable. That is, it should not contain any obviously unfilmable episodes, such as a flying saucer landing in the playground, a teacher tarred and feathered, or the school going up in flames.

To help the students to think up themes the teacher may find that the pump needs first to be primed a little. A few names of characters and objects can be set down on the blackboard for the benefit of any pupils who are devoid of ideas.

Only the briefest plot outline is required at this stage, one from each member of the class. One pupil may suggest the discovery by some children in a forest of an old well, which is found to have magical properties. Another may favour a mysterious hooded figure seen at the window of a classroom. A third may centre the plot on the endeavours of a very small boy to make his name on the football field. In each case the idea need be further developed only to the extent of introducing the villain and other chief characters, and indicating a possible outcome of the adventure. The complete plot outline will not require at this stage to be longer than four or five sentences.

Incidentally, many adult amateur script-writers, working in isolation or pondering in groups round ciné club tables, will be green with envy at the prospect of the teacher-producer with his 35 different plot-outlines to choose from!

57

All these efforts should now be read and corrected by the teacher, who can pick out the five or six most hopeful ones before returning the rest. Together with the class, he will soon be able to decide which idea out of the short list is the most promising. It may well happen that two or even three ideas could be amalgamated into a really worthwhile little story.

The class may now be asked to think up a good title and, each pupil to write suggestions. The title should be brief, original and clear, but must not give away the point of the plot. It will soon be discovered which title suggestion best fits the story.

Now the class will begin to work on details of the chosen theme. At this stage local geography comes in. A map of the home area is drawn by each pupil, based probably on a 25 inches to the mile Ordnance Survey map. On each drawn map the pupil will indicate possible routes to be taken by the persons in the story. In many schools, especially in rural areas, this could involve some actual exterior prospecting by the class with their teacher, to investigate possibilities.

Incidents, all strictly relevant to the main theme, can now be brought in. Eventually the whole story, divided into several paragraphs, is written out by class and teacher in its complete form.

Shooting Script

Now the class must face the task of creating a shooting script or scenario out of this story outline. This is a fascinating and exacting job. The shooting script of a recent fiction film made in our school (see Appendix) occupied Class III for three weeks at an average of an hour a day. The surprising fact is that I saw no signs of boredom, despite the fact that this task amounted to a prolonged series of exercises in composition, grammar, vocabulary, punctuation, spelling and writing.

First the teacher must explain that a shooting script is simply a description, using the present tense, of each little

event in the drama. He can then point out that a shot (a scene taken with one run of the camera's motor) is just like a sentence, whereas a sequence (a series of shots, usually in only one or two locations, forming one episode in the story) is comparable with a paragraph or perhaps a chapter.

Each pupil is issued with a small ruled notebook. They open it at the first double page, and it is explained to them that each left-hand page is for visuals, that is, what the audience will see. Each right-hand page is for sound, to remain blank for the present. Only if it is quite certain that no attempt will be made to add a sound track will every page be used for visuals. A narrow margin is ruled down the left side of the first left-hand page, and is headed Shot No. Another narrow margin down the right side of the same page is headed Distance. The wide centre column is headed Visuals.

Under the word Visuals should be printed the words 1st Sequence, and the number 1 is entered in the left column in the line below that. (See Appendix.)

The first sequence traditionally consists of the titles, including the captions and the credits. But it is popular nowadays to plunge the audience right into the action with a short, appetite-whetting prologue, after which the captions appear. This is purely a matter of preference.

Teacher and class, working together, now take the story outline and break it down into full and meticulous detail, describing each shot as seen by the cameraman and later by the audience. Average shots should not last much longer than four or five seconds, although there may be a number of exceptions where longer or very brief shots will be effective. The best rule to follow here is, the quicker and more exciting the action being portrayed, the briefer should be the shot.

A good start can be made by means of an establishing shot. This, it can be explained to the class, is a shot taken from some distance, often from a high level, to establish or set the scene where the opening action is to take place.

At this stage it should be pointed out that there are three main categories of shot, according to the distance between camera and subject—long shot, medium shot and close-up. These are entered respectively by each pupil in the right-hand column of the page as LS, MS and CU. A good rule is often to start with a long shot, continue with a medium shot and go on to a close-up; and it can be explained to the class why this procedure is so effective.

Whenever a teacher has to use a technical term as he proceeds with the script, it is a good plan for each pupil to enter the word and its meaning in a glossary built up gradually at the back of the note-book. Many of the words which the teacher asks each pupil to enter may cunningly be chosen because they are words liable to be encountered later in other walks of life. A guide to the most commonly used technical terms will be found in the Appendix.

As far as possible, the actual wording of each sentence in the shooting script should come from the boys and girls and not from the teacher. Nevertheless many of the sentences will be along lines already in the teacher's mind. Every experienced teacher is capable of this seemingly hypnotic technique, which is not quite so difficult as it may appear to the layman. In fact, some would say that this is the very foundation of education (the word, after all, means drawing-out)—an eliciting from the pupil, by questioning and hinting, of thoughts which are already in the teacher's head, rather than a direct implanting of facts into the juvenile mind.

Each sequence might include 10 to 30 shots. Various techniques may conveniently be explained and discussed as they naturally crop up. It is remarkable, for instance, how quickly a class of average children can grasp the idea of the cutaway shot (a shot of, say, the expression on an onlooker's face as he sees something happening) and its value in avoiding a jump cut where two consecutive shots make an unnatural break in the sequence.

It soon becomes clear to the pupils why the camera must be moved to a different position with every new shot:

partly for variety, and partly to avoid jump cuts. Of course, this will all become more real to the pupils when the filming starts. But the position of the camera should often be indicated in the script, if it is important.

The young people will also quickly grasp the significance of the height or angle of the camera—low to indicate menace, high for a calm general view (or sometimes for suspense if the actors are looking up).

By the time several sequences of the script have been written, the teacher will find more and more that the pupils are volunteering ideas involving camera and acting techniques, and that it is becoming less often necessary to hint and help the class to think things out.

Thus teacher and class work their way to the end of the shooting script. An alternative method might have been to divide the class into groups, each responsible for the compiling of one sequence in the script. While this would seem at first an excellent plan, in keeping with the project method, it involves in this case serious difficulties. After all, the pupils have no prior knowledge of script-writing technique, and the best way of learning it seems to me to be the actual production of a script in the way I have outlined, in partnership with the teacher.

It may be decided that enough can be learnt by the boys and girls about scripting if they write, say, half of the script, leaving its completion to the teacher working on his own. There may be something in this, and the decision can be left to the teacher. Certainly he should not allow the task to become at all monotonous.

Some film units may discover, after some experience, that the shooting script becomes considerably altered as filming proceeds—so much so, in fact, that one copy of a new and completely accurate script must later be written, after the final editing of the film, so that a proper sound track may be compiled. If this is the case, then naturally it is unnecessary for the shooting script in the first instance to be written on one side of each page only.

When the shooting script is completed, or perhaps while it is in progress, the pupils can be trained in acting for the screen. They will find that this involves an altogether different technique from acting on the stage. As one pupil after another goes through a screen test, the acting becomes noticeably more and more natural, and less and less self-conscious. It is not necessary actually to film these screen tests.

After a reasonable amount of practice at acting for the screen has been undertaken by the pupils, the teacher's attention can turn to the allocation of duties in the production of the film.

Personnel in the Film Unit

From the start, the students will show considerable interest in the duties of the various personnel in the film unit.

The difference between a producer and a director should first be made clear. The children should regard the producer as the person behind the whole project, responsible for all the initial planning, tackling the financial problems encountered, choosing equipment and making negotiations with various Powers That Be, while the director is the man on the set, with personal responsibility for the acting and filming of each sequence.

The teacher in charge of the project is likely to be both producer and director of the film. An exception might be where one teacher, usually a specialist in English, is in charge of the project as far as the conclusion of the shooting script, after which a second teacher, perhaps from the science or technical department, supervises the actual filming, editing and sound mixing.

In some ways, however, the latter arrangement may not be entirely satisfactory. In a school film unit, it is probably as well for there to be some continuity of supervision, with one teacher in charge throughout.

A few schools may have sufficient staff members to permit two teachers to co-operate in running the film unit. One can

be in charge of the class and give instruction, while the other attends to equipment and technical problems. This would help very greatly.

Nevertheless, the absence of an assistant on the set need not in any way deter a keen and determined teacher from running the film unit himself. The problem of discipline will in any case probably be no more difficult here than in any conventional class lesson.

The rest of the duties can be allocated to pupils. Indeed, the virtue of the whole project is that the pupils themselves can do the major part of the work. Naturally the teacher must instruct, demonstrate and supervise where a new procedure is involved; but it is remarkable how quickly a young person is able to catch on, frequently ending up by teaching the teacher.

A group of boys, say three, should first be chosen by the teacher to form the camera team. This is better than appointing one bright boy as cameraman, for we must bear in mind the possibility of his absence on a filming day. Preferably several members of the class should learn the technique of operating the ciné camera. It is, of course, better to choose boys who are both interested and reasonably careful. One boy can concentrate on the actual filming, while another is in charge of the tripod, and a third attends to exposure, spare rolls of film, close-up lens, and filter.

Continuity

Some members of the class may have heard of the term continuity girl, but her importance in the making of a movie will have to be carefully explained. There is, incidentally, no special reason why boys should not do this work instead.

It might be best to appoint three continuity girls. Each can be given a small note-book. The first girl can take a brief note of the appearance of each actor or actress at the start of a sequence, and make sure that this has not noticeably altered by the next shooting session, unless the events

are supposed to be taking place on a different day. I have vivid memories of our first film, "The Wishing Well", for which the six young stars had to wear the same clothing throughout. This involved three girls wearing and washing the same summer frocks day after day for four weeks, rain or shine. I believe these three dresses have never been worn since.

It is surprising how many really bad continuity errors are made in amateur films—a yellow pullover replacing a red one during one class-room lesson; a boy going to school with no tie and going home with one; or even a crew-cut miraculously becoming a mop during an afternoon walk. It is certainly unwise to risk even one member of the audience noticing such a fault. Hence the first girl's notes on continuity of appearance.

The second girl concentrates on continuity of position. She might often be more inclined to use sketches rather than words. Her task is to take notes of the positions of the principal actors and properties; but it is necessary to do this only where a filmed sequence is interrupted by the exigencies of time. For instance, in a classroom sequence the position of each pupil must be noted if the end of the day has arrived before the end of the sequence.

The third girl has the important duty of attending to what we might call continuity of shots. Each page of her book is headed: Reel 1, or Reel 2, etc. As each shot is filmed, she notes down its number, as in the first column of the shooting script. Before each exposed reel is sent away for processing, the reel number should be marked on the envelope. This enables the persons editing the film later to know exactly what shots are on each reel. The procedure is a substitute for the work of the clapper-boy on a professional film set.

Another three pupils will act as a lighting team. It will be their task to adjust the lamps and reflectors for indoor scenes, to see that cable and plugs are properly fitted, and to hold the lamps in position.

A person vital to most films is the one who used to be termed the art director, but who nowadays is very often called production designer. He might be a pupil with a particularly artistic bent, but it is more likely that the producer will ask the school art teacher to take on the job. He will have to organize the layout of a fabricated stage set, if this is called for. Occasionally he will arrange for students to paint a large backcloth. Design of titles might also be left to him, always remembering that the major part of the work should, if practicable, be done by the pupils. Lastly, any experiments in the use of cartoon or puppet technique could be his special responsibility.

One pupil should be appointed to have charge of properties; that is, essential objects to be used in film sequences. These might include a clock, a necklace, a bicycle, a poodle, a bag of gold, a bundle of five-pound notes and so on. The property boy or girl should have a written note of properties required for each sequence, and he or she should check up on this before the film unit goes on location.

Costumes are best left to an obliging homecraft teacher, who should nevertheless try to see that most of the actual work of making the costumes is done by girls and not by herself. In most cases, at any rate in the early efforts of the film unit, pupils acting in the film will probably be wearing their ordinary clothes. But it is an attractive idea to have a colourful, sinister or amusing exception, wearing a costume made at school. With experience, the film unit might embark on a really ambitious costume drama.

Make-up is generally unnecessary when pupils are acting as themselves and not as tramps, countesses, or Chinese mandarins. If make-up is required in one or two cases, the aid of someone associated with a further education dramatic club will be most useful.

The Cast

The cast of the film must be carefully chosen, particularly the stars. The screen tests will reveal that some pupils are

natural and lively, while others remain wooden and unconvincing, no matter how hard they try. Generally a group of five or six class members who are able to behave naturally on request can be selected without much difficulty, with the two or three best as the stars of the film.

There are good reasons for arranging that the rest of the class should all play parts as members of the supporting cast, or at least as extras in crowd scenes, even if they have other duties such as continuity or camera work. All the pupils will want to have the chance, like Hitchcock, of identifying themselves with the film by appearing in it.

A favourite way of involving the whole of a class is to incorporate a chase sequence in a school film. The fact that this is a most unoriginal notion should not deter the director from using it. It has many virtues. It uses all the pupils, keeps them extremely busy, provides excellent exercise and arouses considerable interest among the local community. After all, the chief aim of the project is not to win competitions for originality, but to provide children with work to do.

Besides the personnel already mentioned, there will probably be no dearth of willing helpers outside the film unit.

It is hoped that the producer can depend on the interest, support and advice of the head teacher. The success of the project depends to a very great extent on his attitude. While it is not necessary for him to follow closely the week-by-week progress of the work, he should be sufficiently interested to be willing to make alterations, and sometimes drastic ones, in the normal time-table. Indeed, it is hardly likely that a teacher will be able or willing to embark upon such a project, even using his own equipment, if the attitude of the head teacher is basically unsympathetic.

The co-operation of some other teachers, besides those who have already been mentioned, will certainly be required at various stages in the project. Before the term is finished the film may well have involved the whole school in one way or another.

66

The school janitor may prove one of the most valuable helpers in the work of the film unit. An efficient janitor can be of great practical assistance throughout. He might take the responsibility for the lighting of the indoor scenes. Later he will probably play a major part in preparing for the public showing of the film.

Much interest in the project will be aroused outside the school and some parents may co-operate in occasional sequences which take place in pupils' houses or gardens. Other friends of the school will doubtless respond readily and generously—for instance, a local farmer, shopkeeper, clergyman or county councillor.

Last but not least, it may be desirable to obtain the help and co-operation of the local police. A constable may even take an acting part in the film. If this is required, application in writing must first be made to the chief constable of the county.

Making the Film

There are practical problems during the actual filming which will face the director from the outset. None of these is insurmountable.

First of all, the whole class should be kept occupied. The experience of actually taking part in a film production, and watching the rest of the fascinating procedure from start to finish, may interest the class so much that none of them will give the trouble usually encountered in a class of three dozen students. However, that might be too much to expect. There is always one troublesome pupil; more often there are two or three. This question will be dealt with more fully in a later chapter.

Suffice it here to say that those pupils who really insist on being a disruptive influence, and who long to be the centre of attention, must undergo some form of punishment. It may be the withdrawal of privileges will prove salutary. However, many teachers have found that examples of flagrant breach of discipline are less frequently met with during a film project than during the course of ordinary lessons.

For the purpose of the project, the conventional pattern of subjects and periods will require some modification.

An English teacher would have to put aside the usual routine of language and literature for the duration of the project, and perhaps also history and geography, as far as the filming class is concerned. Sometimes the class will have to remain on location all morning, all afternoon, or even all day. This necessarily involves the indulgence of other departments.

Often, however, the somewhat lengthy periods of time

required either for location work or for working with artificial lighting can be arranged with surprisingly small disturbance to the rest of the school.

It has already been stated that most of the work of the film unit should if possible be done within school hours. But on many occasions pupils are willing, even eager, to carry on working after hours. It would certainly seem a pity to discourage this. When it is suggested to a class that some location work could be done on a Saturday, the response is likely to be surprising, even overwhelming. This readiness to do extra filming or sound mixing work can be a veritable embarrassment.

Very quickly the youthful actors and actresses will discover the vast difference between acting for the stage and for the screen—the continuous and chronological drama of the footlights, in contrast with the film story built up piece by piece like a jigsaw puzzle.

As each shot is filmed, it must be ticked off by one pupil on his or her copy of the script. The director indicates the start of each shot with the words: "Three, two, one—action!"

It will be unusual if much of the film script is shot consecutively. Suppose, for instance, the script involves a class working quietly, all unaware that a sinister figure in the furnace-room is preparing to blow the school up. The class will perhaps have planned, in accordance with the requirements of suspense, that we first see them at work, then the intruder entering the playground, then two pupils at work, then again the intruder creeping into the furnace-room, then the teacher watching the class at work, then a close-up of the intruder's hands as he produces sticks of dynamite, and so forth.

Even the dullest pupils will see at once that the practical way of tackling this is to film all the classroom scenes on one day and the furnace-room scenes on another. When our film unit was making a sequence for "The Miraculous Mandarin", in which thirty pupils were involved in a breathless chase across fields and up and down a slag-heap, the

thief they were supposed to be chasing was absent from school. He had to be filmed running away from them on the first fine day after he returned to school, which was a fortnight later. The completed film keeps flashing rapidly back and forth from pursuers to pursued, and the deception is certainly not noticeable.

The players must learn to ignore the camera completely, and also to ignore those members of the class who are not taking part in the sequence. Although the rule of never looking at the camera unless the script tells you to is easily learnt and obeyed, it is an entirely different matter to portray emotions oblivious of an audience of fascinated or amused classmates. Only practice brings proficiency in this.

It is the director's duty to bring out the best in each actor, demonstrating, encouraging, and criticizing as the filming progresses. Now and then members of the class may be invited to help in constructive criticism.

Shooting

There are a few general rules for using the camera.

The ciné camera itself should be kept still, except when following a moving subject, or (very occasionally, and only when really necessary) when making a slow pan or tilt. While it may be found inconvenient to take a tripod on long journeys or abroad, the photographer can use a chain-pod or lean against a wall. On the other hand, a sequence taken from a moving platform such as a train or a cable-car will be a certain success.

Panning or tilting, using the pan and tilt head, should be sparingly used. A slow and smooth action is best except where zip-pan effects are wanted. A pan or tilt, especially outdoors, should start with a pleasing composition and end with another equally pleasing. A tracking shot, where the camera pans or tilts (or is even pushed along on a dolly) in order to follow a moving person or object, is often a more satisfactory device.

In professional filming, it is frequent practice to take a

The camera may be steadied in a number of ways, besides using a tripod. Leaning against a solid object always gives some steadying effect. You can put one foot in a long loop of string or chain hanging from under the camera and pull the camera upwards until the string is taut. Better support comes from resting the elbows on a nearby object or on your knees in a sitting or kneeling position.

shot more than once and endeavour to approach perfection. But economy demands that a school film unit limit duplicated shots drastically. By repeated rehearsals, an attempt should be made to make the first filmed shot a satisfactory one, though the number of rehearsals should not be overdone.

A shot can often be made longer than the action really calls for, so that there are variations in where it can be cut at the editing stage. For instance, if a girl is to enter a classroom and walk up to the teacher's desk, the scriptwriters may have decided that the camera should first take in a view of the door. The door will be seen to open, and the girl will enter. It is advisable to film the closed door for a few seconds before it is opened. The length of time an audience can be expected to look at a closed door will be decided later when the film is being edited.

However, it should certainly not be necessary to cut a large number of shots short at the editing stage. That is wasteful of film and what is more, the number of joins in a film should be kept to a minimum. In fact, many amateur directors endeavour to edit in camera, that is, they film the script as far as possible in the order in which it was written.

Outdoors

The easiest shots are probably those taken out of doors. The main problem here is undoubtedly the capricious British weather. The most colourful and attractive shots are certainly those taken in bright sunshine with a few white cumulus clouds scudding by. But we cannot always wait for sunshine. If the occasion is otherwise suitable and time is short, then on a fairly bright though cloudy day, a vital scene should be shot rather than left over. If the exposure is correct, it will probably be perfectly satisfactory, though of course it will not match up with shots taken on a sunny day.

The director should encourage his camera team to vary the camera angle, whether the shooting script says so or

not. Often a striking shot, perhaps of an intruder entering the playground over the wall, can be filmed either from an upstairs window or from the ground level. Sometimes a character can be asked to walk straight up to the camera and past it. On other occasions, in order to accentuate a mood of menace, the camera can show only the feet of a character, or perhaps his hands.

There is little difficulty about organizing outdoor scenes if they are in the immediate vicinity of the school. It is when the story demands that the characters appear in a street or a field some distance from the school that one or two new problems appear.

On the whole, it is best when deciding on locations to select places not further than a couple of miles from the school. This means that the class and teacher can comfortably walk there and back, and there is no transport problem. Indeed, the walk should be regarded as a pleasant and useful part of the pupils' physical education. Many young people nowadays do far too little walking, anyway.

In a case where it is decided that part of the film must be shot at a considerable distance from the school, preparations have to be more elaborate. A bus must be hired, and the company must be willing to postpone the booking in the event of unsuitable weather.

It is my experience that if the distance of the location necessitates hired transport, a filming session should last the whole day. Children should be sent home, if practicable, for sandwiches and correct clothing immediately on arrival at school as soon as the director has decided that the weather prospects are favourable and has telephoned for the bus. Incidentally, here the boys and girls may suddenly begin to take an alert interest in the television weather charts.

Despite these complications, a distant location undoubtedly adds great interest to the final film. More important, the scenes could be shot in a neighbourhood of intrinsic educational interest, such as a ruined castle or a glaciated valley.

If it comes to that, there is no reason why the annual school educational excursion should not be combined, for one class at least, with shooting part of a film, or even provide the location of a complete short story.

The most ambitious project of all might be a fiction film, planned in advance, to be made while on holiday abroad. In this event, the best idea would seem to be to plan a repeat excursion to a place already visited once. For example, if the school excursion was to a Swiss village, detailed Ordnance maps of the neighbourhood could be bought from the Swiss Tourist Office in London, and several weeks in school prior to the return visit could be devoted to planning an exciting and colourful story and deciding on attractive locations, most of which would be well known to the teacher and some of the pupils already. This idea, if followed up, could well prove a resounding success.

Thus the duration of a filming session on location might be anything from a quarter of an hour to a fortnight!

Indoors

Indoor sequences present rather different problems. Lighting will be with photoflood lamps. Two at least should be in holders, or on stands, and two or three more can simply be fitted into the room lamp sockets to provide additional illumination. It might be possible, if the producer is a member of a local ciné club, to borrow some of the club's own lighting equipment, and even including full-size stands and booms. The aim should be to have as much illumination as possible without endangering the fuses. As already mentioned, tungsten-halogen lighting is brighter and more convenient.

This type of illumination, with or without stands and booms, is perfectly adequate for medium shots and close-up work. There should be a considerable number of these shots in the film.

A shot which takes in a wider scene, such as a classroom, is more difficult to illuminate adequately, but light from

four or five photofloods will probably serve the purpose. When using a classroom, by the way, it prevents interruptions and pleases the pupils if one of them previously makes out a notice to pin outside the door indicating that filming is in progress.

Corridors and staircases should certainly be used if the story requires them. They add greatly to the interest of the film. They may be rather difficult to illuminate brightly, but this will probably not matter much.

If the school possesses a hall with a good-sized stage it can be imaginatively fitted out with a stage set. Anything from the most simple scene to the really elaborate could be done here. Those scenes which are otherwise inconvenient or impossible to film can be constructed and filmed here, such as a railway carriage compartment or a smugglers' cave. In fact, the stage might be used for most of the indoor filming.

Special Effects

There are a number of camera tricks which are well worth bringing into a school fiction film, partly to entertain the audience when the film is complete, but mainly to stimulate the pupils' imagination and give them something extra to work out. In particular, the kind of "magical" film which boys and girls like to make really must have magical effects.

Many ciné cameras are provided with a choice of speeds. Besides giving the standard silent filming speed of 18 or 16 frames a second, the motor can be made to run fast or slow. The result gives the impression of people moving very slowly or very quickly.

Slow motion is often used in training or documentary films to demonstrate in detail a process or action. It can also be used in a fiction film, to give an unreal effect for a dream sequence.

There is a place in comedy films for fast motion, especially to add fun and excitement to a chase. It has, indeed, been

somewhat uncharitably suggested that the reason why we laugh so much at early Mack Sennett and Charlie Chaplin comedies is that they were almost invariably filmed at a slower speed than the one used when they are projected by modern equipment.

A most useful device found on many cameras is the single-frame mechanism. Using this, the camera operator exposes one frame at a time instead of 18 or 16 each second. It can be used for a number of other trick effects.

For example, it may be necessary to indicate the passage of time. We can scarcely fall back on the ancient device of sub-titles, and it is unwise to rely always on the audience guessing exactly how much time has elapsed since the last sequence.

For this effect the working procedure is as follows. The ciné camera is set up on its tripod, facing a clock dial on the wall. One frame of the film is exposed, and the camera operator gives about half the indicated exposure. This is to compensate for the fact that the shutter does not move at full speed in a single-frame shot. Then the minute hand is moved about a quarter of an inch. Another frame is exposed, and so on. An alternative, probably better, is to expose two frames each time instead of one. The final effect on the screen is of the clock's hands moving steadily round until the required lapse of time has been indicated.

Another use of single-frame technique is for time-lapse cinematography. This is frequently used in educational films to demonstrate such events as the process of growth in a flower; but an occasional time-lapse sequence can be called for in a fiction film.

For example, the camera can be set up directed towards a blue sky with a few moving clouds. Pupils take it in turn to stand by the camera and expose one frame at a time every two seconds or so. This would have to be continued un-interrupted for a quarter of an hour in order to produce about half a minute's film of clouds in a most spectacular turmoil across the sky. This kind of sequence, incidentally,

will provide a splendid superimposed background for a title shot.

One type of comedy shot using single-frame technique is known as a "pixilated" one. This involves taking a single frame of, say, a boy sitting in a chair. The boy's chair is moved backwards an inch while he sits perfectly still, and then another frame is exposed. This procedure is continued as long as required, and the final effect on the screen is of a hapless boy careering backwards across a room on a bewitched chair. Other examples of the use of pixilated technique can readily be thought out by inventive pupils and incorporated into a fantasy film. They could employ objects instead of people, giving a poltergeist effect.

If the camera has no single-frame facility, a possible substitute might be to mount it very firmly and jab at the button with a finger.

If a character or an object is to appear or disappear suddenly as if by magic, the procedure is very simple. The ciné camera is, as always, set firmly on its tripod. A couple of seconds of film are exposed and the camera is stopped. A person steps into the scene and begins the action. The camera is quickly re-started. Any other person in the scene must remain absolutely motionless while the change is being made. Disappearances are worked in exactly the opposite way.

For this purpose a camera with a motor which reaches its normal filming speed almost instantaneously is best. This avoids the over-exposed flash frame at the start of each shot. In some clockwork ciné cameras the instant start can be aided by keeping the motor fully wound.

Reverse Filming

Occasionally reverse filming is required for a fantasy film. This is where the action on the screen appears to happen backwards. Here the camera must be placed or held upside down while the shot is being taken. When the film returns from the processing station, the shot is cut out

of the film, turned back to front, and then spliced back into the film.

It is said to be difficult to make a reversed shot adhere to the rest of the film when using cement; but I have found the joints perfectly satisfactory when using a bevel splicer. If any difficulty is encountered, a cellulose tape splicer can be borrowed and used for this purpose.

A reversed shot made in this way will be slightly out of focus when projected, as the emulsion will be on the wrong side of the film, but this cannot be helped and will probably not be too noticeable. The only way to get over the focusing difficulty might be to send the processed shot away and have a contact copy printed. However, the cost of this would possibly be prohibitive.

Cameras with reverse filming facilities use a simpler method. The film is first run forward without exposing, and then put in reverse and run back over the unexposed section.

Another trick effect is obtained by use of the split lens technique. By means of an effects box, half of the lens of the ciné camera is covered, and a shot is taken, say, of a girl standing on one side of the set, looking towards the empty space. The film is then either back-wound or put through the camera a second time, and the other side of the lens is obscured. The same girl then stands on the other side of the set and faces the opposite way. The effect is of a girl confronted by herself or by her twin.

Double exposure technique of a different kind is much used in ghost films, and the film unit might wish to make use of it. A favourite device, and a most effective one, may be used at the start of a dream sequence, or a sequence in which a character dies but his spirit lives on.

A standard 8 camera, loaded with a new film, and with the motor (if it is a clockwork one) fully wound, is set up on a very firm tripod. The character is filmed "sleeping" or "dead". Only half the indicated exposure is given. Then the camera is stopped, but the character must remain

78

perfectly still. The camera is carefully removed from the tripod without any shift in the tripod position.

Now the lens cap is fitted and the rest of the first half of the film is run off. The film is turned over, and the second side is run off, covered in the same way. The film is turned a second time, and threaded ready for re-taking the first side.

The alternative to this procedure is to wind back the film by hand, in a dark room or using a changing-bag. If the camera has provision for back-wind, the film is simply wound back to the start immediately after the reclining figure has been filmed.

After either of these two procedures, the camera is wound up again if necessary, and carefully replaced on the tripod in eaxctly the same position as before. Again with the iris set at half the indicated reading, the character is filmed stirring from his recumbent position, then standing up and moving off. If he is supposed to be a ghost, the camera can be stopped as he reaches a closed door, and re-started after he has removed himself from the set. The final effect will be of a transparent ghostly figure leaving his other self, walking to the door and passing right through it.

This operation is obviously not a straightforward one but should not be thought too much for the film unit to cope with. One should remember, though, that an opaque ghost can be perfectly satisfactory. In fact, some film-makers feel that the transparent ghost is a much-overdone gimmick. It should also be realized that this technique cannot be used at all with super 8 equipment in its present form.

Trick shots of many kinds should certainly find a place in a school film unit's work. They arouse in the pupils a considerable amount of interest, and kindle their imagination, which after all is what we have set out to do.

After several weeks of intensive work on the part of teacher and pupils, the day will eventually come when the last shot has been filmed. It is then that the class will have to turn its attention to the absorbing task of editing.

Editing and Splicing

When the first 50-ft. reel of film is completed, it is sent off for processing. Within a few days it will have returned, and the class will be all agog to view the rushes—that is, to see on the screen the length of film exactly as it comes back from the processing station.

As subsequent reels are received, it becomes necessary for some rough editing to be done. This involves cutting off any leaders and trailers, removing sequences which have been wrongly exposed, cutting out the first attempt of a shot which has been given a re-take, and putting the remaining shots in their correct order, using the third continuity girl's book of shots as a guide.

There are two possible ways of tackling this rough editing. One is to start with the first reel and splice the successful shots together on a large reel in their correct order. As each 50-ft. reel of film arrives, the shots are cut up and spliced on to the large reel in their correct places, so that as time passes the film gradually grows until it is complete.

The alternative way is to cut up each reel, as it is received, into separate shots, or groups of consecutive shots, which will have to be stored in correct order until the film is complete. They could be stored in a large number of pill-boxes, or compartments on a board, or hung from pins on a wall.

Each of these methods has its disadvantages. If shots are spliced on to one big reel as they are received, there is far too much handling and splicing, and also cutting film where it has already been spliced. Nevertheless, many amateurs use this method, despite the double work and the wear and tear on the precious film. On the other hand, if the second method is used, an editing rack must be constructed, and a

Once the film is cut, each shot should be kept separate and numbered. Paper clips or clothes pegs attached to a suspended strip of wood serve the purpose. Alternatively, film can be hung from a piece of wood with pins in it laid across a film bin. Another method is to store them coiled inside box lids glued to a board.

safe storage place must be found. The pupils, too, will have no chance to watch the film growing, although they will certainly see each reel as it arrives.

The more professional and satisfactory way is the editing rack method, and an extra piece of construction work for the technical department is surely no disadvantage.

A group of pupils must be trained in the work of splicing. Here we run into a difficulty. Obviously it is impossible for a whole class to perform this task at one time. The majority of pupils certainly cannot be allowed to sit around and wait while one privileged boy, or the teacher, works at the editing equipment. It would be just as undesirable for the teacher to do the work himself at home.

For some classes the best way may be for one pupil to splice while the rest do conventional written work of some kind. The only other way is to ask for volunteers to do the rough editing and splicing at lunch-time or after hours. There will in all probability be no shortage of offers; in fact, one may expect a waiting list of those wishing to learn how to use the editor and splicer.

Viewing

It is when this rough editing and splicing has been done that the whole class comes back into the project. The film is now critically viewed on the screen. Then it must be explained to the pupils that it has to undergo cutting for smooth action. Many shots will be obviously over-long. When an actor enters a scene from one side, the first frame of the shot should generally be one showing part of his body, and not the empty space before he appears. Action here and there will be slow to the point of tedium. A cherished scene, spoilt by one member of the cast glancing at the camera, must be ruthlessly cut. Where an error in continuity has unwittingly crept in, the scissors must again be used. Occasionally a few shots must be slightly rearranged.

The procedure in cutting for smooth action is as follows. The film is run through the projector until any pupil notices

A titling table could be constructed in the school workshop (*top*). Main features are: 1, a switch for the lights; 2, two photoflood lamps with diffusing reflectors to illuminate the titles; 3, a cut-out section to take the camera lens directed downwards; 4, the base to hold the title cards. Using two chairs (*bottom, left*) a titling board may be supported and the camera mounted lens downward towards the titles which are laid on the floor between the chairs. A horizontal titler (*bottom, right*) allows objects to be placed in front of it and supports two lamps. This model allows a camera without a zoom lens to be moved back and forth for advancing and receding titles.

one of the faults already outlined. He or she calls out a suggestion, and after two or three have been called out, the projector is stopped, the lights are switched on, and each pupil writes in his or her note-book, at the end of the script section, the numbers of the shots to be altered, and brief notes of the amendments to be made, for example:

48: Cut where Jean looks at the camera.

53: Cut before John appears in doorway.

59: Insert in the middle of 58, which is too long.

The projector is then started up again, and the next two or three amendments noted in the same way.

This task should not take too long. After completion one of the note-books is used as a guide for the splicing team, who go ahead, cutting and splicing as instructed by the class. When the splicing is complete the class will view their film again and submit it to the kind of criticism which a newspaper would give to a professional film.

Again, the film involves the work of the whole class, and not a few privileged members, or indeed of the teacher alone. This is in keeping with the aim of the project.

Titling

The best place for drawing and filming the titles is the art room, and no doubt the art teacher will be very willing to co-operate.

There is a simple way of producing titles, or making the film's captions and credits. This involves the purchase of a titler, a gadget to which the ciné camera is attached. A set of standard capital letters is also bought. The appropriate letters are fixed, by magnetism or some other means, to a small board at the correct distance from the lens. Sometimes the apparatus is fitted with lamp-holders, one at either side. These lamps are to illuminate the titles.

It is, however, quite unnecessary for the school film unit to purchase this kind of equipment. There are two other ways of doing the job which will not involve extra expenditure.

The technical department could be responsible for the construction of a titler from plans and instructions which are available in several ciné text-books and periodicals. This is an appropriate way. It offers a further opportunity to involve another department in the project.

Alternatively, it is perfectly possible for the film unit to produce good titles without any apparatus at all, using only a tripod.

With either of these methods the actual titles are drawn by the pupils under the guidance of the art teacher. This is distinctly superior to using purchased letters, as far as the school is concerned. It introduces to the pupils a technique valuable in itself—the technique of lettering and layout. Hand-drawn letters, too, are often extremely effective.

If the method without apparatus is to be used, the first step is to set up the ciné camera on its tripod in the room, facing a wall or blackboard. If the camera has a close-up lens, this is fitted in place. If it has a focusing lens, this could be set at, say, 3 ft. Using measuring tape, the appropriate distance from film plane to subject is measured and the camera is placed at that distance.

A sheet of paper is pinned on the wall or board, or it may be stuck with cellulose tape. This must cover an area a few inches larger all round than the view seen in the viewfinder.

Now consider the problem of parallax. With all cameras which do not have a through-the-lens reflex viewfinder system, the viewfinder is set higher than the lens, so the tendency in a close-up is always to cut off the head of the subject. This has to be guarded against when any close-ups are filmed.

Many ciné cameras have a mark on the viewfinder to compensate for this error. One camera used by our film unit had a useful mechanical adjustment.

The correct position could be found by trial and error, but often this is not practical.

A much more satisfactory method, used by many film-makers, involves the use of a parallax correction card.

A piece of card and a thin sheet of paper, both of the same size, are required. Suitable dimensions might be 6 in. by 4 in. A hole is cut in the centre of the paper, just big enough to fit over the lens of the ciné camera. The paper is then fitted squarely on to the front of the camera, with the longer sides of the paper parallel to the base of the camera. The outline of the viewfinder is marked on the paper with a pencil. The paper is now removed from the camera and turned over. The outline of the viewfinder can be drawn again on the back of the paper, making use of the impression already made. Diagonals are carefully drawn in the small rectangle. Now the paper, still face downwards, is placed squarely on top of the card. The point where the diagonals intersect is marked on the card through the paper by means of a pin, and the shape of the lens hole is drawn on the card. The paper is now no longer required.

Through the point which was marked with the pin, two straight lines are firmly drawn in ink, parallel to the edges of the card, and thus at right angles to each other. The lens hole is carefully cut out.

To use the correction card, it is placed squarely on the title sheet with the hole at the centre of the sheet. The camera, on its tripod, is positioned so that the heavy ink lines meet in the centre of the picture as seen through the viewfinder.

This method can be used at any distance, and is a really easy solution to the parallax problem.

It is best to place the lettering of a title so that there will be a reasonable width of border around the letters as seen on the screen. This looks effective and serves also to guard against the titles being cut off at the edges.

Another method of titling is to set up the camera on the tripod as before, but this time pointing the lens straight down, and placing the titles on the floor. It is almost essential to do it this way if the titles are to be animated.

Wording

When the appropriate size of the space to be occupied

86

by each title has been decided, the pupils can set to work to deal with the actual wording. It is usual practice to begin with the main captions, thus:

<div align="center">

NEWMAINS
SECONDARY SCHOOL
FILM UNIT

presents

The
Miraculous
Mandarin

An
Oriental
Phantasmagoria

Starring
Ann Wood
Ian Feely
and featuring
Class S.III

</div>

Then follow the credits, or acknowledgments to those who took part in the project, thus:

<div align="center">

Story and script
by
Class S.III
who were also
responsible for
editing
and
sound mixing

</div>

More specific acknowledgments can come next, mentioning by name those responsible for camera, continuity, properties, costumes, make-up and lighting. Production designer and director come last.

The final section of the titles is the cast list, thus:

<div align="center">

CAST

</div>

The Mandarin Ann Wood
The Thief Ian Feely
First Boy	Robert Taggart
Second Boy David Baird
First Girl	Laura Ellison
Second Girl Eleanor Topping
Teachers S. Waddell
					G. Taggart
					J. D. Beal

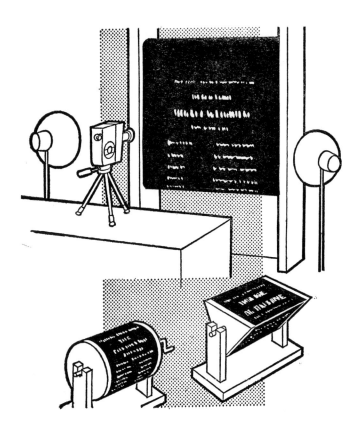

Long and moving titles may be filmed using (*top*) the school blackboard, roller type; (*bottom*, *left*) an old tin mounted on an axle and revolved with a crank; or (*bottom*, *right*) a wooden block with three faces. Both of these devices could be constructed in the school workshop.

Finally comes any special acknowledgment, for example to a farmer, a parent or a chief constable.

Although the entire list of titles cannot appear on the screen at one time, it is not always best to divide the list into sections.

An effective way is to use a roller technique. The titles can be done on a long strip of black paper of the required width. While the camera remains fixed, the titles are moved past at a speed which allows for comfortable reading time. As a general rule, there should be just sufficient time for the audience to read rapidly through each line twice.

A roller blackboard can be used if the camera is in the upright position. Alternatively, if the floor is used for the titles, it is very easy for a couple of boys to draw the title list slowly and smoothly along.

A really effective refinement is a static background with moving titles superimposed. This can be done by filming through a sheet of glass which has white letters painted on it. A much more effective way is by double exposure of the film, but this is not possible at present with super 8 equipment. The procedure is here described for the benefit of those using standard 8.

The method for a ciné camera fitted with backwind is as follows. First film the background, giving half the indicated exposure. Wind the film back an appropriate distance. Then film the moving titles. The resulting sequence will be exceedingly effective.

It will be more effective still if the background is itself moving. For instance, it could be a view of a forest with leaves and branches swaying, the water lapping on a sea shore, or blue sky with a few white clouds scudding past.

A similar effect can be obtained using cheaper equipment. Start by filming the background, giving half exposure, at the beginning of the first side of a standard 8 film. Let the camera run on, rewinding the motor carefully when necessary without jolting, until that side is fully exposed. Use the second side for filming any other sequences. Now

expose the first side of the film a second time, this time filming the titles, knowing that part or all of the first side can be used for this if necessary. The second side must then be run through again with the lens of the camera covered so that the film ends up on the correct reel.

This procedure may well be preferred to the other alternative, which is to open the camera in the dark and backwind the film by hand.

Some prefer to film the titles first, and it has been suggested that this produces a clearer effect.

The actual lettering must be white on black for double-exposure colour work, and the black must be really jet black, without any reflections. The background on which the words are superimposed should be fairly dark, with no large fixed light-coloured areas.

For film units using super 8 equipment, the titling method using painted letters on glass will have to be tried when a superimposed title is required. Many film-makers, of course, regard a straightforward title as perfectly satisfactory.

Another popular title treatment is to allow the words or letters to appear one at a time. This is very effective, and also straightforward to do, using stop motion. Film the first word, or letter, for a few seconds. Stop the camera and add the second word. Film the first two words, and so on. The camera must remain perfectly still throughout and should be one which is not guilty of over-obvious "flash frames".

The letters of a title can even be made to slide about in an almost human way and take up their positions one by one. This is done by the single-frame technique.

The camera is directed downwards to the floor or, if it is outside, to the grass. One pupil places the first letter, cut out of card, at the side of the scene. Another pupil exposes one frame of the film, using, if possible, a cable release for steadiness. Then the first pupil moves the letter about half an inch and a second frame is exposed. This goes on until the first letter has finally taken up its position. The same pro-

Animated titles. A line can move across the map by drawing in the next stage between frames. The same method may be applied to a written title. Transfer letters make neat professional titles and may be quickly added one by one. Scraps of paper can form themselves into words. The words could be made first then cut up and gradually reassembled. A piece of modelling clay could form itself into a word by gradual moulding between frames.

cedure is followed for the remaining letters until the title is complete. The final effect is highly diverting, and well worth the pupils' trouble.

In a similar way, a line can make its way across a map to indicate a journey.

An intriguing alternative method, and one which takes up much less time, has been suggested to me by my young son. A large sheet of drawing paper is stretched out in a wooden frame. The letters required are sketched out in reversed writing very lightly in pencil on the back of the paper. A pupil using a felt-tipped pen draws the words behind the sheet of paper, and the front is filmed in the conventional way. Thus there is no need for single-frame technique. As a matter of fact, the above method seems to offer distinct possibilities in cartoon work.

When the filmed captions and credits return from the processing station, they are spliced into the film. Where they are inserted is a matter of taste. They may appear in the conventional places at beginning and end, or a full-length film may begin with a short prologue and follow with the titles. The cast list might well be left to the close of the film, to precede the words "The End", but this again is a matter of opinion.

Puppets and Animation

An ambitious school film unit will not be content to make conventional films for long. Sooner or later, members will want to learn how the various kinds of puppet and cartoon films are made. At first a brief animated sequence may be incorporated into a normally-photographed film. Later, an entire film using animated technique may be attempted.

Puppets actuated by strings or worn as gloves may be used for film work. It is possible that the school has already made and used puppets of one kind or another, in which case a model theatre may have been constructed. If not, then the film unit could certainly do this. All that remains is to film the puppet play from start to finish, using photofloods,

and then perhaps add music and narrative, as described in a later chapter.

An entirely different technique is called for in the production of an alternative type of puppet film. Here the puppets and other objects are not actuated mechanically at all. This is really a form of animation as the single-frame technique is used for all the shots of moving figures. The puppet figures must be stiff but pliable, and able to remain fixed in any position. Simple but attractive models can be made of pipe-cleaners for this purpose.

The method of filming is similar to that described in the previous chapter. One frame is exposed at a time, giving half the indicated exposure. Between exposures the figure is moved very slightly, say a quarter of an inch at a time. It is, needless to say, a method requiring patience. The whole class can work at writing the story and making the figures and properties, but the actual animation and filming must be left to a few.

A good working method for some films is to have the camera pointed down and focused on a board, on which numerous familiar objects are brought astonishingly to life— a box of matches, two safety pins, a pair of pliers, a piece of string and so on. A road safety film using miniature cars is an example where this set-up would be easy to work with. Such experiments are most valuable in encouraging inventiveness in young people.

The final result may be highly effective and diverting, and the first experiment may bring forth numerous highly original suggestions for subsequent films.

Animated technique can be used to bring a painting to life. This involves single frames again. One pupil may make a colourful painting of a person's head and shoulders. Exact dimensions of the head are taken, and about thirty head-shapes are cut out of paper. The first is frowning and the last, smiling. In between, pupils will endeavour to draw twenty-eight stages between the frown and the smile.

The ciné camera is now set up, and several frames are

exposed of the frowning face. Then, one by one, each stage is substituted for the previous one, and two frames are exposed for each stage. The last stage, the smile, receives several frames. The effect is of a painting coming startlingly to life.

Two-dimensional paper working models can be the basis of simple but very satisfactory animated films. In every case, pupils can be responsible for the story, drawings, animation, filming, lighting and sound. A combination of single-frame technique and working models can be used. Good examples of the latter can be found in a well-known series of cut-out books.

Blooping ink, an opaque liquid which dries to a matt finish, can be used to produce striking animated effects when painted directly on to the exposed live-action film itself. This seemingly intricate process is done with a very fine paint brush, painting on the individual frames of the film. It is not so difficult as it sounds, if used only for simple effects. For instance, if a figure in a fantasy is to vanish and then reappear as something entirely different, a wobbling black blob can be painted in on the intermediate frames to bridge the gap between disappearance and re-appearance. Other uses of this technique will no doubt occur to inventive pupils.

The advanced methods used by professionals of the calibre of Disney, Hanna and Barbera, or Halas and Batchelor are far too advanced for a school to tackle, but the rudiments of the fascinating cel method could be explained to interested members of the film unit.

Adding Sound

There is something not quite satisfying about a silent film. The reason for this, no doubt, is that sounds accompany all the things we see in real life. Even in the earliest days of film, a pianist was hired to extemporize music in the theatre to suit the changing moods of the film, and nowadays we regard sound of some sort as an essential accompaniment to almost any film.

As with the actual filming, the pupils must not expect to begin recording until a great deal of preliminary paper work has been done.

The class must first produce the note-books in which they wrote the shooting script. It will be recalled that each right-hand page was left blank. The sound script should now be entered on those pages. The procedure is exemplified in the script extract to be found in the Appendix.

It is suggested that a narrow margin be ruled down the right side of each right-hand page. The rest of the page should now be divided into two equal parts. The first of these three columns should be headed Live Sound, the second Recorded Sound, and the third Seconds.

Live Sound may consist of narrative, dialogue, effects and music. Recorded Sound involves recorded music, and sometimes sound effects discs.

The class must first decide how much narrative is necessary in order to make the story clear. A start might well be made at the opening of the film where a sentence or two can do much to establish the mood of the story.

As always in this project, the actual sentences of the narrative should be elicited from pupils, and not supplied by the teacher. The narrative may be in the first or third

person, though the former might be preferred for a school story.

Teacher and class now work their way through the script, selecting places where explanations or connecting links seem to be necessary, and composing good sentences to fit. These are written in the first column on the right-hand page, each starting immediately opposite the appropriate visual. There might be lengthy sequences with no narrative at all, while other sequences may require several sentences. It is probably as well to have a good summing-up sentence near the end.

In early attempts at filming, it is advisable to keep dialogue and effects to a minimum, as synchronization—fitting sound exactly to visuals—will present several problems. These, however, can be overcome, as we will see later.

It is certainly most effective if a bag of gold thrown into a pond is accompanied by a hearty splash, or if a boy turns to his friends and is heard to shout: "He went that way!"

It is, however, a very good idea during filming to place the speaking character in such a way that his mouth is not clearly seen. For instance, the boy shouting to his friends could turn slightly away from the camera to do the shouting, and not towards it. This difficulty cannot always be avoided (for example, in the splash incident), and the device should not be used too often in one film.

In later efforts, after some experience, lip synchronization (usually termed lip sync) can be successfully achieved. But it is best to avoid it in the unit's first sound film.

Where dialogue or a sound effect is to be used, it should be indicated in the same column of the sound script. Sounds not involving spoken words should be either written in red or printed in capitals, to prevent any confusion owing to the one column being used for both speech and effects.

Another kind of sound effect is used as a continuous background, often for several minutes. Examples are: playground noises, street traffic sounds, bird song, classroom chatter, and so on. The class should decide which sequences in the film would benefit by having such a back-

ground. Then a brief description of the required sound can be entered in the script.

Music

When narrative, dialogue and effects have been dealt with and written in, the class must consider the intriguing business of music. This brings the producer immediately face to face with the frustrating problem of copyright.

The commercial record catalogues are crammed with examples of recorded music which are just crying out to be used as backgrounds for amateur films. The infuriating fact is that normally none of this treasure-house may be used in Britain for re-recording on tape, as this is breaking the law of copyright.

It is technically illegal even to make a tape recording of a disc in the privacy of your own home and play to no one but yourself, unless you pay copyright fees to the composer, the artists and the recording company. Further, the aforesaid company will almost certainly refuse permission, whether the hapless amateur offers to pay a fee or not.

An obvious action suggests itself. This is to ignore the law and record without permission, as many amateurs have been doing for years. They have nearly always got away with it and indeed, it is hard to see how they could be discovered perpetrating their crime if the tape is recorded and played in the privacy of a house.

However, a school is in a very different position, and it is strongly recommended that this pirating should be avoided by the school film unit.

What, then, is to be done?

Some gifted amateurs have composed and played their own music. As a matter of fact, this would be a splendid idea for the project if the music teacher considered it a practical possibility. Some school film units have produced their own very effective home-made music. If this is done, it must be indicated, in the left-hand column of the sound script, where the live music starts and finishes.

The association known as the Institute of Amateur Cinematographers (I.A.C.) now operates a scheme which gets over some of the difficulties of copyright. Members of that organization who pay an additional fee are permitted to re-record on tape any records of bands, orchestras or choruses performing music which is out of copyright. This means, of course, that modern compositions may not be used. You would be safe with Bach or Vivaldi. However, many cinematographers are of the opinion that a record of established music is unsuitable for a film sound track because it tends to attract attention to itself and away from the film.

Mood Music Discs

Fortunately, there is a solution that should please everybody; and I would recommend each producer of school films to take advantage of it. Members of the IAC in England and Wales, or the Scottish Association of Amateur Cinematographers in Scotland, may purchase special mood music discs through these associations, and use them on payment of a recording fee. These are records produced mainly for professional use, and are regarded by HM Customs and Excise as free from purchase tax.

The discs are, in the main, of high quality, both in performance and as recordings, and they are designed to cater for almost any mood. Most of them have a duration of about three minutes per side, but some extremely useful ones consist of snippets of mood music, each lasting only a matter of fifteen seconds or so. Catalogues and details are available from:

IAC, 8 West Street, Epsom, Surrey; or
SAAC, 16/17 Woodside Terrace, Glasgow, C.3.

The pupils must now study the sound script with a view to deciding where background music is required. It is often a mere matter of opinion whether natural sounds or music would be more effective. All the student need do at this

98

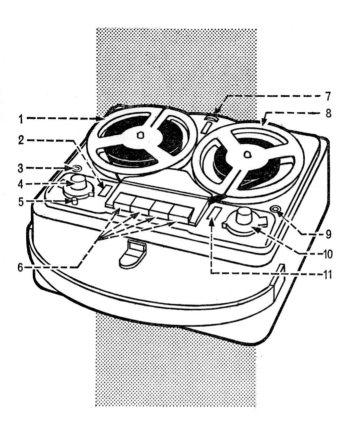

Tape recorder features. 1 and 8, tape reels; 2, on/off indicator; 3, microphone input; 4, combined control for on/off, rewind, stop, normal play, pause and rapid forward wind; 5, speed selector; 6, control keys, forward rewind, record and replay and stop key; 7, footage counter; 9, microphone input for superimposition; 10, recording level control, microphone volume control, speaker cut-out; 11, recording level indicator.

stage is make a brief note lightly in pencil in the Recorded Sound column of the script, indicating the sort of music required, such as chase music, weird music, threatening music, morning music, and so forth.

The film unit must not forget the value of silence on a sound track. There is no need for every second of a film to be accompanied by noise. The pupils will readily recall, for instance, the tension engendered in a circus by the breathless hush just before the climax of a high-wire act. The aim should be for every sound and every silence on the sound track to mean something.

Preparing the Sound Track

By this time the class should have become reasonably conversant with the operation of a tape recorder. If not, a series of demonstrations to a small group at a time, giving each pupil an opportunity to work the machine, will no doubt be found the best way, rather than a lecture to the whole class.

It is not practicable to record a film sound track by using a tape recorder "wild", or entirely separate from the projector unless a stroboscopic disc device is used, and this is certainly a tiresome method, depending on constant readjustment by the projectionist while the film is being shown.

On the other hand, if a synchronizer of one sort or another has been purchased, either separately or as part of the projector, the class can go ahead confidently and prepare the sound track on tape. Even if the film unit has purchased a stripe projector, it is still advisable, in order to produce a really satisfactory sound track, to use a synchronizer such as the Synchrodek and a tape recorder for the first step in putting sound on to film.

There are many types and makes of tape recorder, and there are distinct advantages in a machine with provision for parallel playing. However, if a recorder has not this facility, it can still be used to produce a first-class sound track.

Tape recorders are generally provided with alternative speeds. These are usually $1\frac{7}{8}$, $3\frac{3}{4}$ and $7\frac{1}{2}$ inches per second, the rates at which the tape runs through the machine. The most satisfactory for general purposes is $3\frac{3}{4}$, and indeed many synchronizing devices can work only at this speed. It is reasonably economical, and gives at the same time perfectly acceptable sound quality, especially in the more up-to-date machines.

Recording tape is manufactured in various thicknesses: standard, long play, double play, and triple play. The longer tapes for a given spool size are naturally thinner and, although they are nowadays remarkably tough, it is probably better when using a loop synchronizer to select standard thickness, or at any rate a tape not thinner than long play.

There are two reasons for this. Standard tape is tougher than the rest and can stand up well to the strains imposed on it by these synchronizing devices; and it is thicker, and accordingly unlikely to slip when held between the two rollers. However, manufacturers generally recommend long play tape for four-track machines, for good technical reasons. If the film unit's recorder has four tracks, it is better to take the manufacturers' advice.

Several types of microphone are manufactured for use with tape recorders. The best known are crystal, moving-coil and ribbon. If a moving-coil microphone has been supplied with the tape recorder the film unit is fortunate, for this is the best for most purposes. However, the cheaper crystal type will certainly suffice until the film unit becomes affluent enough to buy a good low-impedance moving-coil microphone, which will give a much more lifelike recording. It is unlikely that the tape recorder has been provided with a ribbon microphone, which is sensitive but expensive and delicate.

The Narrator

The teacher's task is now to select from the class the

pupils with the best voices for recording narrative. This work may be done either by one student or by several in turn. If several are to be used, they can be pupils with contrasting voices, each telling one part of the story.

There will doubtless be much rivalry for the honour of being selected as a narrator. For this purpose the teacher might test every member of the class, or, better still, ask for volunteers. In either case it is a good idea to play back all the recorded voices and invite criticisms from the class. This is of considerable educational value, as it teaches children both to speak clearly and to criticize others constructively. Often the best and most pleasant narrators are by no means the most intelligent pupils. This fact may give some of the duller pupils their chance to shine.

The recordings should first be made purely for selection and practice. Actual recording of the main sound track comes later.

Sound effects may be of a natural or artificial nature. Tape recording text-books and books of school plays for tape recording give plenty of hints about the artificial kind—crushing cellophane for a crackling fire, speaking into a cardboard box for voices in a tunnel, coconuts for horses' hoofs, dried peas in a box for rain and many others. In many cases people find that genuine sounds are better if it is practicable to record them: the best splash is obtained by dropping a stone into water, and the best sound of running feet is obtained by recording running feet.

Records are obtainable commercially which consist of useful sound effects of all sorts, and these might save a great deal of trouble. But there is much to be said for a school film unit making its own noises.

Continuous sound effects, such as a chattering class, boys shouting in the playground, or pupils running along a school corridor, are best recorded at some length on a separate sound effects tape. Exterior sounds can easily be recorded by placing the microphone at an open window.

The sound effects tape is retained until extracts from it

can later be re-recorded on to the main tape. This entails the use of a second tape recorder, which can usually be borrowed readily enough.

Adding Music

The musical part of the sound track is practically a project in itself, and a highly fascinating and rewarding one. Here the music teacher will no doubt wish to help.

Let us suppose that two mood music discs have been purchased through the IAC or the SAAC. One of these provides, probably on one side, extended music suiting the mood of the greater part of the film. This we may call the "theme music". The other record comprises perhaps a dozen tracks which we can regard as musical sentences, each track lasting around 15 seconds, and each track suiting a certain mood.

It is just as well to re-record all this mood music on to tape, for convenience and to prevent unnecessary wear of the discs. A note should be taken of the number, on the digital counter fitted to the tape recorder, where each piece of music starts.

Now each pupil, taking a new page of his or her notebook, will be asked by the music teacher to note down in turn the title of each piece of music and describe briefly the mood which each seems to suggest.

This is an exceedingly interesting exercise in itself, and the results can be most revealing. The teacher should now take a consensus of opinion about each piece of music in turn, and then can make a decision, in co-operation with the class, as to which pieces are likely to be of value to the film. Those compositions which do not suit this particular film can probably be used another time.

The next task is for two members of the class, working together, to time each piece of music precisely, one pupil calling out the duration while the other operates the stop-clock. The rest of the class can note the number of seconds opposite the title and mood of each piece. It is a good idea

to time also each part of the main theme music, naming each part, for example:

"Romance for Children":

A: Grand opening (slow):		18 secs.
B: Main tune (medium):		44 secs.
C: Playful tune (fast):		34 secs.
D: Main tune repeat (medium):		32 secs.
E: Grand ending (slow):		28 secs.
Total:	2 mins.	36 secs.

Mood music titles can now be entered in the appropriate column of the sound script.

Recording the Sound Track

There are four or five alternative methods of recording the final sound track on tape.

The most obvious way is to link up tape recorder and projector by means of the synchronizer, connect the microphone, set up the record player with a direct monitoring connection to the tape recorder and have a team of pupils ready to make the appropriate sound effects and speak the appropriate lines. Tape recorder and projector are switched on together and the sound recordists watch the film and fade in and out the right sounds at the right moments.

If things become difficult, the tape recorder can be switched off at any time and switched on again when all is ready. Switching off the tape recorder involves switching off the linked projector. This stopping and starting is possible with most synchronizing devices. In fact, some synchronizers can also be run backwards while coupled to a suitable tape recorder, when erasing and correcting a mistake in the recording. Otherwise the film and tape must be started at the beginning each time.

The method just outlined can be hectic, to say the least, especially with a complicated script. It also has the disadvantage of recording projector noise, unless the machine is blimped, or fitted with a soundproof cover. The method also subjects film and projector (and recordists!) to a good deal of wear and tear. Nevertheless, some amateur film-

104

Recording the sound track. 1, commentary read into microphone while reader watches image on screen; operator, 2, controls recording and switches tape recorder and projector on and off together; music recordist, 3, puts on record according to cue sheet and image on the screen.

makers use no other method, and with a fairly simple script it can provide a satisfactory result, including the fading and mixing of words and music.

A stripe projector can be used on its own, without a separate tape recorder. This, of course, has the advantage that the film can be easily and rapidly run back and forth in the projector until the sound track is complete. However, the remarks already made about wear and tear apply just as strongly here, and the disadvantage of a definitely inferior sound quality must be borne in mind.

Pilot Tape

Fortunately, there is a straightforward and trouble-free method of using synchronized projector and tape recorder, which can be relied on to give a first-class result. This is the pilot tape method, and I would recommend it unreservedly.

If the aim is absolute lip sync with no inaccuracy, perforated tape (the type known as Cinetape A) is to be recommended. If the tape recorder is a four-track machine, the tape perforations will take up only one track, leaving three tracks unspoilt. This enables the recordist to use the parallel-play technique (see p. 112) if required, despite the perforations.

To begin the pilot tape procedure, teacher and class examine the script from the start, shot by shot, and inserting an asterisk at every place where a new sound is to begin. In each case the asterisk should appear just beside the number of the shot; that is, at the left side of the left-hand page. Also, wherever there is a change of location or the start of a new sequence, another asterisk is inserted. Then the asterisks are given consecutive numbers from start to finish.

Now the group of pupils who specialise in splicing have a small but important job to do. A 3-ft. length of black leader must be spliced immediately in front of the first picture on the film. Another piece should be spliced on to the end.

If the film unit is skilful or fortunate enough to have no black spoilt film left over from previous efforts, then this is very easily made, perhaps while filming the titles. The procedure is to cover the lens of the ciné camera and run off 15 seconds of film for each 3-ft. length required.

To the black leader at the start of the film must be spliced 3 ft. of white leader. This is the piece of white film which will be found spliced to the start of each reel as it is received from the processing station. An arrow should be marked in indian ink on the white leader, where it meets the black.

The tape to be used for recording must have a coloured leader (not red unless Side 2 is being used), about 5 ft. long. Then the first 5 ft. of the actual recording tape must be measured, and a small piece of white or yellow cellulose tape stuck on the outer (glossy) side, 5 ft. from the start of the recording tape. An arrow pointed downwards should be drawn on the cellulose tape.

The tape recorder, the synchonizer and the projector are now placed in the positions described in the instructions for the use of the synchronizer. The projector should be situated so that the picture will be shown on a wall a few feet away. At this distance the light will be intense enough to make the small picture easily visible in daylight.

The projector and the tape recorder are switched on and allowed to warm up. This is important, and should never be omitted when synchronized film is about to be shown. After ten minutes or so, the projector is switched off, and the film threaded so that the arrow marked on the white leader is at the gate of the projector.

The tape spool is now fitted to the tape recorder, which should have its speed indicator set at $3\frac{3}{4}$ in. per second. If there are four tracks on the recorder, the switch should be set at track 1. The tape is placed so that the arrow is at the recording head, and the end of the tape leader is fixed to the core of the empty spool.

Whether a loop synchronizer or a Synchrodek is being used, the loose tape is now threaded on to the device

according to the instructions. Then the right-hand tape spool is rotated until the tape is tight, and all is ready.

Pencil Tap System

This procedure, although it sounds highly involved, is actually quite within the capability of twelve-year-old non-academic pupils, after a little practice. But recording the pilot tape should be done by the teacher alone, at least the first time. He should sit beside the projector, facing the screen, with a copy of the script before him and a pencil in his hand. The microphone is placed about a foot in front of him, but not close to the projector.

The teacher switches on the projector, and also presses the record and erase buttons on the tape recorder. Both machines will start in unison, the tape recorder controlling the speed of the projector.

Every time the film reaches a stage marked with an asterisk on the script, the teacher gives the table near the microphone a sharp tap with the pencil. Immediately after the tap, he reads aloud the appropriate red number. If any lip sync is called for, the tap must be specially precise. There should be no difficulty at all in following this procedure.

At the moment when the words The End vanish from the screen, to be followed by black leader, the teacher should say "End". Now the projector, synchronizer and film may be put away. The rest of the work is done using only the tape recorder.

The two pupils who have become expert at operating the stop-clock now have the responsibility of timing each interval between pencil taps (i.e. between asterisks) to the nearest second or two. One pupil calls out the number of seconds each time, and the other jots the number down in the last column of each right-hand page in his script. He should follow this rule: the duration of Sound Number 1 should be marked in the last column of the line where the asterisk has been entered indicating the *start* of Sound Number 1.

108

Pupils soon get into the way of doing this kind of job. In fact, I find that they revel in the responsibility. But if this timing work is considered too exacting for pupils to accomplish with accuracy, the teacher can do it. When the task has been completed, the rest of the class enter these numbers in their own copies of the script.

Now a start can be made at filling in sounds on the pilot tape. As each sound is recorded, it will automatically erase the sounds already there.

When a sound is about to be recorded, its exact starting-place on the tape can be found with no trouble at all. The tape is played at high volume until a tap is heard, at which point the pause button is pressed. Then, while that button is kept down, but not too firmly, the left-hand spool is turned clockwise (i.e. in the rewind direction) by hand, until a sort of slowed-down tap is heard. The tape is now turned a little further in the rewind direction—say a quarter of a revolution—and held there by the pause control. Then the stop button is pressed and the pause control released.

All the stopping and starting throughout the recording should be done by means of the pause control, and never by the stop and play/record buttons on their own. In this way the recordists will avoid recording unpleasant clicks.

Compiling the Pilot Tape

The first sounds to be recorded on the pilot track should be narrative and dialogue. These can easily be done by the selected pupils, preferably at a quiet time of the day. The volume control should be kept fairly low, and the pupils should generally speak close to the microphone. In this way noises from the playground or other rooms will be kept to an absolute minimum.

Sound from the record-player and from the second tape recorder are recorded by a direct monitoring connection, not using a microphone. The quality of sound recorded by monitoring is incomparably superior.

Every effort should be made to avoid any abrupt starts

and stops, even when using the pause control. If a piece of music is rather too long to fill a gap, the stop-clock must be used, and the music rapidly faded out at an appropriate point by means of the volume control on the tape recorder. The fading should begin three or four seconds before the next pencil tap. Immediately after the fade, the pause button must be pressed. This will ensure that the next pencil tap will not yet be wiped out.

When a short extract from a previous recording, say of playground noise, is to be put on to the pilot tape, the additional tape recorder should be started up first. The sound is re-recorded in the exact place on the main recorder tape, using the stop-clock in conjunction with the pause button and volume control of the main recorder.

It is extremely effective if about four bars of the opening music are heard before the first visuals (that is, during the black leader), rather than at the same moment. The final music can end at precisely the same moment as the words The End vanish from the screen. This effect can be ensured by running film and tape through to the end of the music, and stopping the tape recorder and projector immediately after the last note. At that point the film should be cut and black leader spliced to the The End caption.

Some recordists go further with the pilot tape technique by sticking small pieces of numbered adhesive tape at all the places where taps are recorded. This method ensures that cues are not obliterated.

Once or twice during the recording of the sound track, the class will certainly want to check their progress. Projector and tape recorder can be coupled and film and tape run through at any time. Here and there, pupils may suggest minor amendments in the sound track, and these can be attended to. Lip sync in particular must be perfectly accurate. Half a second too soon or too late is not good enough. Precise placing of lip sync can be achieved by trial and error if necessary.

Eventually the time will come when the boys and girls

Compiling the pilot tape. The teacher first records the pilot track by tapping with a pencil at points marked in the script and speaking the appropriate number. Using these cue marks and information in the script pupils can then record one by one the music, dialogue and effects on the two tracks.

will be able to see and hear their film in its finished form. Any final tidying-up of the sound track can now be done.

Using Four-Track Recorders

The method of sound recording which has just been explained entails very few real difficulties for teacher or pupils and should produce a really satisfactory result. There is, however, a refinement available to any film unit with a four-track tape recorder with provision for parallel playing. This has replaced superimposition methods on four-track machines.

With the parallel system, the pilot tape can be recorded on track 3, and all the sound recording can be done on track 1. These two tracks are running in the same direction on the tape, and by means of a simple switch the user can play both at once. In this way synchronization is made easier. Errors can be erased without erasing pencil taps. Lip sync phrases can be played along with pencil taps to make sure that they are exactly spot on. Finally, track 1, the actual sound track, is played by itself, and the pilot track is no longer required.

A slightly different method, resulting in a distinctly superior sound track, is also available to a film unit using this type of tape recorder. The working method here is only slightly more complicated, and is undoubtedly worthwhile.

The pilot tape is recorded on track 3, as before. This time, the narrative, speech and sound effects are recorded on track 3, obliterating some of the pencil taps. The music is then recorded separately on track 1. With this method music can be played as a quiet background to narrative, dialogue or sound effects. The music is faded just before the first words are spoken, and faded in again at the end of the speech. If a mistake is made in one track, it can be re-recorded without affecting the other. Eventually both tracks are played together in synchronization with the film.

Any other continuous background noise may be used in the same way as music.

If this method is used, the columns on the right hand pages of the script note-book should preferably be headed 'Intermittent Sound' and 'Continuous Sound'.

This mixing effect, with one sound smoothly dissolving into another instead of replacing it, is extremely pleasing, although it is not necessary or desirable to use it throughout the film. Where it is required, it should be indicated on the sound script by the use of the word "mix" instead of the words "fade in" or "fade out".

Some four-track tape recorders provide for what is known as a duoplay facility (see p. 53), either incorporated in the recorder or as an optional accessory. The device consists of a pre-amplifier and earphones.

The procedure with duoplay is straightforward and foolproof. The pilot tape method is followed, only this time the script should indicate extra points, where the music will begin to fade, in addition to the marks previously described. The fading process should in each case be planned to last only three or four seconds. It should also be made quite clear in the script where the music is to fade right out, and where it is to remain as a subdued background to other sounds.

Projector and recorder are linked up through the synchronizer, the film is run through, and a pencil tap, followed by a spoken number, is recorded at each mark on the script. All this is recorded on track 3. Now the projector can be put away.

The pre-amplifier is connected to the stereo socket on the tape recorder by means of the plug and flex supplied, and the earphones are plugged into the pre-amplifier. The microphone and the record-player are plugged into their respective sockets on the tape recorder.

Using track 3 again, the dialogue is recorded as previously described, erasing the appropriate pencil taps, but not, of course obliterating the taps which refer to music.

Now the tape is wound back to the start, and the recorder is switched to track 1. The record-player is made ready, and

the appropriate music is recorded on to track 1. At the same time, the recordist is listening through the earphones to track 3, the dialogue track, which also still retains pencil taps referring to music. Whenever he hears a pencil tap indicating a music fade, he begins to fade the music being recorded on track 1, so that it will have reached a reasonably quiet level by the time the dialogue begins, three or four seconds after the start of the fading. At the end of that section of dialogue the music is faded up to its previous level.

This procedure, though it sounds involved, is easier than using only the stop-clock. The main thing to watch is the level of each sound. The best volume of voice and music can only be found by experiment, which the pupils will find very interesting in itself.

All pencil taps can be erased in the usual way. Eventually tracks 1 and 3 are played together, using the parallel switch, in synchronization with the film.

To use the multiplay technique, the same equipment is employed, but in this case there is a direct connection from the pre-amplifier to the tape recorder, by means of a special flex and plugs. Here the recordist listens, as before, to the dialogue on track 3 while he records the music, which he can also hear, on to track 1. But this time the dialogue is recorded, along with the music, from track 3 on to track 1. In this way he will obtain a single sound track (track 1), and track 3 may be erased later.

An alternative to the "pencil taps" system, incidentally, is simply to note down the number showing on the tape recorder's digital counter at each point.

A school film unit with a stripe projector has now a further task to undertake. The completed sound track must be transferred from tape to the striped film. The Synchrodek should be used for this.

The working procedure is as follows:

If the stripe projector has adjustable speed, the mechanical link is connected between Synchrodek and projector. The speed of the projector is adjusted until the hand of the

114

Synchrodek dial remains at any constant position. Once this is obtained, the tape sound can be transferred to the striped film.

Although the resulting sound film will have lost some sound quality in the process, many people will consider it quite good enough. The sound will be permanently wedded to the visuals, even if the film has at some time to be cut. There will be no problems if, one day, the sound film is sent away for showing on a strange projector, or for entry in a competition.

Incidentally, a Synchrodek may be used in conjunction with an editor-viewer, instead of using a projector. Some users regard this as the best way to record synchronized sound, especially where lip-sync is called for.

Experienced film-makers use more elaborate methods than those I have outlined. They utilize several sound sources on separate tapes, and employ a mixer to combine these on one tape. This procedure demands experience and additional skill. It may be investigated after the Film Unit and its producer have gained some experience using one or more of the methods described in this chapter.

Co-operation in School

As we have seen, the film unit project is designed as far as possible to involve the whole class from start to finish. It is also meant to involve most, if not all, of the other departments of the school.

It is possibly most convenient, from the outset, for the project to be under the direction of an English teacher. As the work progresses, however, it soon becomes evident that, far from it being a monopoly of the English department, many other branches of knowledge are every bit as vital to the project as English.

Nevertheless, in the initial stages the chief preoccupation of the class is in thinking up story ideas, followed by hammering out a script. This is English with a purpose, and the English teacher will no doubt take care that each pupil realises the importance of a tidy, well-written and carefully spelt and punctuated film note-book. The glossary of technical terms will grow considerably during the course of the project, and many teachers have found ways of making sure that the school library, especially the section containing books on photography, film, acting and recording, is in constant use throughout.

Many ways of involving English in the project will occur to the teacher. During the filming, when the curiosity of local inhabitants is aroused, the pupils could write a newspaper report, not *in vacuo*, but for actual publication in the local newspaper. This can be a competitive or joint effort, but in either case the pupils all play their part. A further progress report, with photographs, will no doubt be welcomed by the same newspaper. Other daily or weekly papers might be interested too.

When the film is complete, many letters will have to be written by the members of the film unit, inviting former pupils, parents, friends, teachers and a few Very Important People to attend the first public showing. It is surprising and gratifying to see with what loving care most of these letters are written. They are not examples of A Letter to My Aunt Thanking Her for a Present; they are Letters To Be Posted. The pupils are fully aware of the difference.

To some teachers the chief point of the project is the opportunity it gives for dramatic self-expression. Very few teachers of English are satisfied with the average halting, stilted, expressionless classroom one-act play, read from a book. This use of ciné dramatic technique gives a new and different opportunity to these young people—an opportunity to express themselves, both visually and aurally, within the framework of their own scheme.

Subjects for Films

An offshoot of fictional film-making is the adventure-type episode taken from literatuie. While they are familiar with writing for the screen the students might attempt a simple script of an incident from a good book. I have found many such attempts astonishingly good. Another possibility is that the plot of the school film could be based, however loosely, on episodes from a famous novel or short story.

The project can involve another branch of English, the criticism of other people's stories and films. If it encourages youngsters to subject to constructive criticism every cinema or television film they see, it has awakened their perception in a valuable way. This in fact is the experience of many teachers who have run a film unit.

History in many schools is treated in a lively and topical way, to arouse the ordinary pupil's interest in just one theme at a time, rather than plodding through kings and queens and centuries. Schools using this modern approach could tackle an appropriate theme such as the fascinating

117

history of the cinema, an art form which constantly and significantly affects their lives. There may also be an historical background to a school fiction film. In this case, study of the theme may constitute a major part of the term's history course. The customs and costumes of the era involved will be investigated in great detail, and with a particular interest derived from the pupils' own participation.

Geography, with its modern accent on local study, finds a link with the project in the early stages when the pupils are studying, mapping and visiting possible locations in their neighbourhood.

The science department may be concerned more than any other with the project. An elementary study of light, lenses, the sensitized film, the camera, processing, the photo-electric cell and the recording of sound could find a place in the science curriculum while the film project is in progress.

With the construction of sets and properties, the technical department will sooner or later find itself deeply involved in the film project. Apart from that, the pupils in their technical lessons can use their ingenuity in making ciné gadgets of many kinds, from an editing rack to a titler. It may also be necessary to construct a screen, footlights and a proscenium, with mechanism for the hand operation of curtains for use in film shows. The technical department may also maintain the ciné camera, editor and projector.

It has already been suggested that the art teacher might well be the film unit's production designer. Not only will he explain composition and the use of colour to the class, he will also teach lettering and layout for titles. The actual filming of the captions and credits will probably take place in the art room. Also, any experiments in trick photography and animation might well be his special interest. When the time of the première draws near, the art department will be responsible for drawing attractive posters to advertise the event in local shop windows.

The special interest of the music department is, of course, the sound track; but something more ambitious

than listening to and selecting mood music records might occur to the music teacher. Could not the class compose a theme tune, to be played by a young pianist or even sung by a youthful soprano? Other instruments, some more musical than others, might also be called into service—or even constructed. Stranger things have happened.

In the homecraft department, the girls may be asked to make costumes and stage curtains. Perhaps also they could study film make-up. No doubt the cookery teacher will later co-operate with the film unit in supervising the girls while they make fudge and toffee for sale at the interval during the première.

Those pupils taking a commercial course will no doubt want to type out the newspaper reports which the pupils have written. Letters to the more important guests at the première can be typed by them too. If a film has a historical background, notes on this may be typed and duplicated.

The physical education instructor could be called upon to play an important part in the project, if any chase or rooftop sequences are required. A film may well involve scenes on the sports field. A fleeing miscreant might even be expected to climb up one of the ropes in the gymnasium. The possibility, too, of a rough-and-tumble fight scene should certainly not be ruled out.

The mathematics department will unexpectedly find itself faced with a most important matter to deal with at the close of the term's project. When the première is over and the equipment put away for the session, it will be necessary to cost the whole effort—to calculate in detail the expenses of the whole thing. Pupils could produce a balance sheet of the whole project taking into account purchase of equipment, film stock, properties and materials, buying and selling of refreshments sold at the première, proceeds of the collection, and the sale of still photographs to parents and friends. Mathematics students could also calculate frame areas and screen-to-projector distances for the various film gauges.

It would be a mistake, then, to see in the film unit project

a trivial substitute for serious study. On the contrary, a large amount of academic work is required throughout.

Neither need the project obliterate all thoughts of a Term Examination. At the time when other classes in the school are being given written tests to measure their attainment during the term, the class which undertook the film project might answer questions, in writing, on many aspects of filming. They could explain how suspense is injected into a melodrama or describe the principles and pitfalls of acting for the screen. Results of this unconventional sort of examination will in all probability be every bit as satisfactory and useful as the traditional kind. Perhaps more so.

Presenting the Film

When the sound film is at last complete, students can think about presentation. After all, the film is not going to be put away to gather dust. It is going to be proudly shown to a waiting world—or so the pupils would like to think. The world première should be as carefully thought out as the film itself.

The best way to study film presentation is to visit a cinema. This is easily done. The manager of the local picture-house will in all probability be delighted to welcome the class on some mornings to the projection room and backstage in his cinema. For this purpose they should be divided into small parties. It is surprising how fruitful this kind of visit can be. The children will have an opportunity to compare a professional 35 mm. projector with their own little 8 mm. machine. They will also watch the operation of lights and curtains, and the screen image masking device, and perhaps even operate them themselves. Also they will learn the secrets of reel changeover and arc adjustment. If the school is near a professional film studio a visit might be arranged too.

When the film is complete, preparations for the première can begin. This event may take place in late autumn or early winter, or be postponed until just before Christmas.

For presentation a suitable hall will be needed. Even if the main film lasts only a quarter of an hour, there will probably be a regiment of parents, friends and former pupils—not to mention present pupils—who will gladly roll up to see it.

If there are no stage curtains in the hall, a proscenium with curtains and coloured footlights could be constructed. This is a task for the girls in the homecraft class and the boys in the technical class. It will add great effect to the presentation. But if the hall is unsuitable or a proscenium appears too ambitious, a plain screen will suffice.

The school film will probably not be lengthy, and a few supporting films should be booked to fill out the programme. The choice is wide, and two or three 16 mm. or 8 mm. general interest or comedy films are a most acceptable way of starting the programme. The school newsreel could also be shown. The full show might last for about two and a half hours.

When the date has been fixed, the posters drawn and issued, and invitations sent out, the film unit must turn to details of presentation.

Stage Signalling Device

Assuming that the hall has been equipped with curtains and stage lighting, a scheme for working the lights is needed. There should be a device to give the stage hands the signal when the projector is about to be started up.

First, the science department can co-operate by rigging up a switch, battery, and small torch bulb in a holder. The switch (or bell-push) is attached to the projector table, the bulb holder and battery fixed somewhere near the light switches backstage, and switch and bulb connected unobtrusively by long double flex.

A code of signals for this device could go something like this:

Start of a film:
4 flashes: Be ready.
3 flashes: Footlights on, house lights out.
2 flashes: Curtains open.
I flash: Footlights out.

End of a film:
3 flashes: Footlights on.
2 flashes: Curtains close.
I flash: House lights on, footlights out.

Emergency:
I long flash: House lights on, curtains close.

The system, of course, depends on the house light switches being backstage. This working method is immeasurably superior to the projectionist shouting "Lights, please!" every now and then.

The drill is as follows. The projectionist (who could quite well be a pupil) is ready to start a film, and gives the warning four flashes. Then he gives three flashes. When the house lights go out, he starts up the tape recorder and projector (or the 16 mm. projector alone). Immediately after this, he gives two flashes, and the curtains begin to open. When he sees the first visual, he gives one flash, and the footlights fade out. The show has begun.

Incidentally, it is a good idea to watch the progress of tape and film with the aid of a pocket torch for the first few seconds of the film.

In the unfortunate event of a film breaking at a bad splice, the long flash warning is given, and the stage hands, who must be ready at any time, switch on the house lights, or one of them, and close the curtains. This looks better than leaving a blank screen while things are being attended to.

The life-saver in the event of a break is a piece of cellulose tape. There should be three or four slivers of this stuck to a convenient part of the projector housing.

When a conventional film (16 mm. or 8 mm.) is being shown, not in synchronization with the tape recorder, the procedure is very simple. If the break is below the gate of the projector, the cellulose tape does the trick of making a

122

temporary join. If the break is above the gate, the film is drawn down so that the break comes below the gate, and the cellulose tape is used in the same way. It is unnecessary to mend the break with the splicer until after the show.

Surprisingly enough, a break is not really a disaster even if the projector and tape recorder are coupled by a synchronizer. It is just a matter of stopping the tape recorder and the projector together; drawing down the upper end of the broken film below the gate, unless it is there already; and using the cellulose tape. The recording tape is tightened up on the recorder, and recorder and projector are started up together again. The loss of sync will probably be slight.

Of course, the same procedure as at the start of a film (p. 122) is used when re-starting after an emergency break.

When the projectionist sees that the film is nearing its end (say five seconds before the closing title), he gives three flashes, and the footlights come on. When The End appears, he immediately gives two flashes, and the curtains begin to close. Lastly, as the last visual vanishes, he gives one flash, and the house lights go on as the footlights fade out.

During the interval, girls from the film unit can sell refreshments. At the end of the project film, which should also end the show, there is no reason why the leading players should not make a brief personal appearance on the stage. The trouble is, so many members of the class will have taken an active part in the production that it would only be fair for the entire class to take a bow. The producer will no doubt feel that they deserve it.

Film Competitions

After the first presentation the school film might be entered in one of the local, national or even international competitions. Whether the film has any chance of success or not, the idea of entering it will appeal to the pupils, and the adjudicators' comments will be most valuable.

The pupils may wish to visit the festival where the winning films are shown, whether their own effort has been successful

or not. Also it might be worth considering either a visit to a film appreciation society's meetings regularly with interested members of the school film unit, or even starting this kind of society in the school itself. Fiction films of the calibre of the superb "Mikhali", sponsored by British Petroleum and available for a nominal fee, are both thoroughly enjoyable and genuinely educative, and can prove most valuable stimulants to the children's critical faculty.

Some Questions and Objections

It would be too much to expect this whole revolutionary concept of a pupils' film-making project to meet with no criticisms or objections, either inside or outside school.

There are still hundreds of teachers, and even some head teachers, who customarily designate all projects as frills and all new methods as gimmicks. If a teacher has a lifetime's experience of lecturing to a room full of silent and obedient pupils hanging on his words, he is not likely to take kindly to the bustling and sometimes hectic activity of a class-room film studio. Even less is he likely to approve of teacher and class spending a whole day on location running up and down hills in the sunshine. Some parents, too, who may chance to witness this sort of thing, might begin to wonder when the lessons are done.

Upsetting the Time-table

There is a commonly-held objection that a film-making project upsets the time-table. This is really an objection to any extensive inter-departmental give and take. Teachers who take this view will sooner or later have to face the inescapable fact that, far from being a wild experiment, the flexible time-table and the activity project or centre of interest are now accepted in most countries as the definitive educational pattern for today and the foreseeable future. As the educationists rightly never tire of reminding us, when working with average pupils we are not teaching subjects. We are teaching boys and girls.

When teachers raise the further objection about loss of discipline, we must point out that this really begs the question; for it makes a tacit assumption about the meaning

of discipline which is accepted by fewer and fewer teachers and educationists today.

If one takes discipline to mean the kind of rigid law and order just described, then there can be no doubt that a filming project often destroys discipline. But then, so does a woodwork class, a cookery class or a physical education class, where the pupils are constantly active in both mind and body. Disciplinary problems very frequently stem from boredom; and this is surely less likely to arise in a project which fascinates most members of a class.

Many branches of learning which were once considered to be merely vast repositories of facts, to be silently conned on pain of dire physical consequences, are now regarded as opportunities for active, cheerful and enthusiastic work. Geography and science are obvious cases in point, where excited chatter (always about geography or science) is welcomed, and mute submission rejected. When group assignments are tackled, we must expect, and indeed be glad of an incessant movement and conversation in our once-silent classroom. A similar atmosphere must at times be expected to pervade the classroom when it is transformed temporarily into a film studio.

Black Sheep

One of the major difficulties of working this kind of project is one which troubles every teacher from his first timid entry into a classroom as a teacher until his day of retirement. What do you do with the "dead weight"?

The problem of the "black sheep" is not peculiar to project work. It occurs in every kind of lesson, from spelling to geometry. There is certainly no simple answer. The pupil can be chastized, ostracized, ignored or psycho-analyzed, or perhaps all four in turn. But afterwards he remains as he was, a thorn in the flesh not only of his teachers but of his fellow-pupils too.

If he is cowed into silence, he sits doggedly refusing to work. If he is compelled by sheer bludgeoning to saw, sing

or climb ropes like his classmates, he delights in attracting attention by making a clown of himself. If he is finally put in a corner and compelled, by fear, to draw, add or write, he produces something which is without meaning or value to anyone, least of all to himself.

If there is an answer, surely that answer lies in the very project work which I have outlined. Somehow the teacher in charge of the film project must contrive a task which involves the recalcitrant in a lively participation. Such pupils are generally at their least objectionable when they have something both active and purposeful to do.

The script of our film "The Miraculous Mandarin" calls for the appearance on paper, by magic, of fifty lines, intended to be written by an erring schoolboy. Naturally, the lines had to be written by someone for the purpose of the film. I must say I was taken aback, and was given to think deep thoughts about the nature and purpose of punishment, when I was confronted by a rush of volunteers from some of the less amenable members of the class, falling over each other to write the lines.

A hesitant teacher might well ask if the whole project is not demanding far too much from these average or below-average pupils.

This would seem a valid point. A fiction film is a highly specialized art form. So how could a film of acceptable standard be created even by a group of intelligent but un-skilled adults, let alone a bunch of non-academic youngsters?

In the first place, the question makes a completely false assumption. The aim of the project is certainly not to produce a first-rate film, any more than it is to produce budding actors and film technicians. The intention is to encourage a class of boys and girls to work enthusiastically together for a common purpose. It is the means, not the end, which matters. If in working at this project the pupils' eyes have been opened to the value of co-operative activity, then the purpose of the project has been served.

Secondly, it is truly astonishing how much of this difficult

technique can in fact be assimilated by average children. They make great strides in learning camera sense in a matter of days; they operate a ciné camera or a synchronized sound system like old hands after a few demonstrations; and they find themselves talking excitedly and with easy familiarity about continuity errors, tracking shots and lip synchronization in a surprisingly short time.

Teachers' Problems

What about the teacher, then? Does this project expect far too much of him? He must not only quickly acquire skill and knowledge of a specialized subject which may be altogether new to him. He must also be ready to give up many hours of his spare time, either at midday intervals or (worse still) at a weekend.

The teacher who lacks experience in actual film-making need not be afraid of finding himself bogged down by technical problems so that the too-ambitious project grinds to an ignominious standstill. To make a personal illustration which I feel must be typical, the first school film I directed, "The Wishing Well", was also the first production with which I had been even remotely concerned. I had never owned a ciné camera or tape recorder. The film was, I must add, a considerable success, despite its obvious faults.

Secondly, the surrender of much spare time must be accepted by the teacher in charge with more or less equanimity. I have found it highly encouraging when a dozen pupils have begged me, day after day and week after week, to give up another half-hour at lunch-time so that they could do some more splicing or sound mixing.

This, in fact, is where the real worth of the project becomes evident. It is summed up by the pupil who, after carefully setting up the ciné camera in a suitable position, beams at the teacher, all unsuspecting, and remarks, "This is better than work!"

Appendix

APPENDIX I

Extract from a Script

"THE MIRACULOUS MANDARIN"

Winner of the Bryce Walker Cup for the Best Novice Film at the
Scottish Amateur Film Festival, 1965.

Story, script, acting, photography, continuity, lighting, editing, narra-
tive, dialogue, sound effects, musical arrangement, sound recording
and mixing by pupils of Class S.III, Newmains Secondary School,
Lanarkshire, under the direction of J. David Beal.

Shot No.		Visuals	Distance
		1st SEQUENCE	
		Prologue	
1	*1	Establishing shot: school: tilt down from roof to pupils and teacher.	LS
2	*2	School Road, Newmains, from above: teacher's car arrives; pupils walking.	LS
3		Boys' playground from above.	LS
4	*3	School Road and Manse Road from above: pupils arriving.	LS
5		Railing of boys' playground from above: boys standing around	LS
6		Church Avenue from above: tilt down to cars in Manse Road.	LS
7		School Road from Manse Road: pupils arriving and standing around.	LS
8		Boys' gate: pupils and teachers arriving and entering playground.	MS
9		Girls' playground: line of Class S.III girls: pan to end of line.	MS
10		Molly and Eleanor at end of line: Eleanor holding Chinese ginger jar.	MS
11		Jar held by Eleanor: tilt up to label at top of jar: "Chinese Ginger".	CU
		2nd SEQUENCE	
		Titles	
12	*4	Captions (still).	CU
13		Credits (rolling).	CU

130

Live Sound	Recorded Sound	Seconds

1st SEQUENCE
Prologue

"Theatre of Romance": 43
opening bars and main theme.

Street sounds; *(Fade out.)*
pupils' voices.

(Fade out.)
It looked like just another school
day. We sauntered up the road as
usual; the teachers got out of
their cars and strode up the road
as usual; but somehow we in the
Third Year couldn't help the feel-
ing of something strange.
There was magic in the air.

Fade in:
"Theatre of Romance":
from trombones' entry.

(Music ends.)

2nd SEQUENCE
Titles

"Way Out East": 103
opening bars; plaintive melody;
final repeat.

3rd SEQUENCE
Painting the Jar

14	*5	Playground: girls' feet: entering school.	MS
15		Door of school: girls entering.	MS
16		Gate and door of school: last girls entering.	LS
17	*6	Inside art room, looking towards door: S.III girls enter.	MS
18		More girls and art teacher enter.	MS
19	*7	Eleanor hands ginger jar to teacher, who places it on table as object for painting.	MS
20	*8	Front row of desks: Molly and Elizabeth sit down and produce drawing paper.	MS
21		Molly starts to draw outline of jar in pencil.	CU
22		Betty's face: tilt down to her painting (just started).	CU
23		Morag's face: tilt down to her painting (nearly finished).	CU
24	*9	Girls leave art room, passing teacher.	MS

4th SEQUENCE
Stealing the Ginger

25	*10	Staircase outside art room: boys descending.	MS
26	*11	The last boy, Bobby, stops at door of art room.	MS
27		Bobby looks at ginger jar and licks his lips.	CU
28	*12	He tiptoes into art room.	MS
29		He looks round furtively.	CU
30		Bobby's hands removing lid of ginger jar; pieces of ginger are shaken out of jar on to table.	CU
31		He puts jar on table, picks up and pockets some pieces of ginger, and puts the other pieces back into jar.	MS
32		He replaces jar in position and puts on lid.	CU
33		He tiptoes out of art room.	MS
34		Corridor and main door: Bobby makes for main door and goes out into play- ground, closing door behind him.	LS

Live Sound	Recorded Sound	Seconds

3rd SEQUENCE
Painting the Jar

Occasional traffic noises. · · · · 29

Slight classroom sounds. · · · · 9

Mr. Taggart explained what we · · · · 10
were to do.
We all began to draw the outline · · · · 29
of the Chinese jar that Eleanor
had brought; and by the morning
interval, our pictures were really
colourful.

Bell rings. · · · · 7

4th SEQUENCE
Stealing the Ginger

Hurrying footsteps. · · · · 8

Bobby was very fond of pre- · · · · 5
served ginger.

"Scenes and Occasions": · · · 43
No. 7.

(Music ends.)

5th SEQUENCE

The Playground Fight

35	*13	Boys playing in playground.	LS
36		Boys pushing at each other, then breaking up and moving towards the left.	MS
37	*14	Boys gather round Bobby.	MS
38		Bobby produces pieces of ginger from his pocket.	CU
39		He gives out ginger to five boys.	MS
40	*15	1st boy spits out ginger.	CU
41		2nd boy spits out ginger.	CU
42		3rd boy spits out ginger.	CU
43	*16	Boys begin to move towards Bobby.	MS
44		Boys advance menacingly; Bobby backs slowly away.	MS
45		Boys' feet advancing.	CU
46	*17	Scuffle.	MS
47		Boys jump on Bobby, from above.	LS
48		Boys pushing Bobby's head down.	CU
49		Scrimmage over Bobby, from above.	LS
50		Bobby's face emerges from scrimmage.	CU
51	*18	Playground, from above: Scrimmage breaks up.	LS
52		Boys' playground, from above: boys form into lines.	LS
53		Teacher supervises while lines of boys move into the school.	LS
54		Last lines leave playground; teacher follows boys into school (zip pan).	LS

6th SEQUENCE

The Experiment

55	*19	Science room: bench with weird and wonderful apparatus.	MS
56		Science teacher enters and begins to explain the apparatus.	MS
57		1st boy listening.	CU
58		2nd boy listening.	CU
59		3rd boy listening.	CU
60		4th boy listening.	CU
61		Bobby listening; somewhat dishevelled.	CU
62	*20	Teacher continues explanation; then pauses, and goes out of room.	MS
63		Bobby produces piece of ginger from his pocket.	CU
64	*21	Bobby has an idea.	CU
65		He gets up and comes out of his seat.	MS
66		He reaches bench.	MS

134

Live Sound	Recorded Sound	Seconds

5th SEQUENCE
The Playground Fight

Playground noises.		14
Bobby thought it might be an idea to let some of his friends taste the ginger first.		15
There was something most peculiar about the flavour.		8
	"Theatre of Romance": middle section (to discord).	9
	"Scenes and Occasions": No. 12.	13
Bell rings. For the time being, anyway, Bobby was "saved by the bell". He felt pretty sore, in more ways than one. The ginger had only brought him pulled ears, ruffled hair and skinned ankles.		37

6th SEQUENCE
The Experiment

It was in the science room that things really began to happen. We were, as always, completely fascinated by Mr. Waddell's explanation of the exciting experiment he was going to show us. *Fade in: home-made scientific music. (Fade out.)*		34
Mr. Waddell told us that he had forgotten to bring the nitroglycerine from the store-room.		15
It was Bobby's chance to get rid of his piece of ginger.		12

135

67	*22	He drops his piece of ginger into beaker of yellow chemical, and there is a vivid flash.	CU
		(Black blob painted on each frame of film above beaker fills space until Mandarin appears in next shot.)	
68	*23	Bench, and blackboard behind it:	MS
		Mandarin appears behind beaker and in front of blackboard.	
69		Mandarin bows, facing camera.	CU
70		Mandarin bows to boys, side view.	MS
71		Mandarin turns slowly to door, then vanishes.	MS
72	*24	Science teacher returns; he stands at door, gesticulating furiously; he shouts at the boys.	MS
		(Camera at low angle; teacher's mouth not visible.)	
		Black film.	

Live Sound	Recorded Sound	Seconds
	"Way Out East": main theme	17
	(Fade out.)	
Mr. Waddell: "You will write out fifty lines each for making such an appalling din!" (Spoken above loud class noise.)		7

APPENDIX II

Co-ordination of the Curriculum

Language and Composition
Story ideas discussed. Place of hero and villain in fiction. Building of characters. Suitable settings.
Writing individual story ideas. Class write full treatment. Class write script. Writing narrative and dialogue for sound track.
Speaking and recording words for sound track.
Building up glossary of technical terms and of other difficult words encountered.
Setting down captions and credits.
Writing newspaper reports. Writing letters of invitation to the Gala Première of completed film.
Criticism by pupils of their own completed film. Criticism of other people's films, amateur and professional.

Drama
Acting scenes from literature for the screen. Acting self-written scenes. Acting the final script. Speaking dialogue for sound track.

Literature
Reading books and selecting suitable extracts for filming. Writing extracts as film scripts.

Library Work
Research into historical, literary or geographical background of theme. Research into costumes and customs for film with historical theme.

History
Study of history of the cinema. Possible study of historical background to school film. Visits to ancient monuments which will feature in school film. Filming historical features of local area.

Geography
Study of local area (mapwork and fieldwork) with a view to finding suitable location. Mapping route taken by characters in film story. Intensive study of areas used as locations, e.g. hills, river valleys, etc. Investigation of local industrial, cultural and scenic features for possible documentary filming.

Science
Study of sensitized film; processing; camera and ciné-camera; light and lenses; photo-electric cell; projector. Study of sound-recording on disc and tape; microphones; loudspeakers. Study of filming and editing technique.

138

Mathematics
Study of comparative film gauges and image areas on screen. Costing of project.

Technical
Construction of sets and properties; also possibly stage proscenium. Maintenance of filming equipment and of lighting for filming and stage presentation. Construction of editing rack and titler. Possible construction of animation desk for cartoon work. Possible construction of puppet theatre.

Art
Production design. Study of composition and colour. Painting sets and properties. Possible making of puppets. Lettering and filming of captions and credits. Preparation of special effects. Drawing posters advertising Première. Animation (cut-outs or cels).

Music
Selecting mood music records for sound track. Mixing musical part of sound track. Possible composition and performance of theme music and songs.

Homecraft
Making and altering costumes. Making stage curtains. Use of make-up. Making confections for sale at Première. Catering for important guests at Première.

Commercial
Typing historical, literary and geographical notes about theme of film. Possible typing of script. Typing letters inviting guests to Première.

Physical Education
Planning and executing of chase or fight scenes. Walking to location. Possible sporting theme for film.

Religious Education
Possible film with religious or ethical theme.

Modern Studies
Field study and local visits.

Language Study
Sound film in a foreign language with sub-titles in English.

INDEXED GLOSSARY

ACTION. The movements of people or objects in a scene. . 69

ANGLE. The viewpoint of the ciné camera when a shot is being taken 61, 72–3

ANIMATED EDITOR. An editor-viewer. . . . 44

ANIMATION. The art of giving apparent movement to inanimate objects on film 92–4, 118

APERTURE. The size of the camera lens diaphragm opening, which governs the amount of light transmitted to the film . 34, 48

ART DIRECTOR. The name formerly given to the Production Designer of a film 65, 118

ARTIFICIAL LIGHT FILM STOCK. Colour film stock which is balanced to compensate for the warm colour of artificial light . 27, 40

AUDIO-VISUAL AIDS. Apparatus designed to assist the teacher by making use of sound and vision 12

BACK-WIND. On some ciné cameras, the facility for winding the film backwards, so that the same section of film may be exposed twice 28–9, 38, 89–90

BLOOPING INK. A black, opaque, quick-drying ink which may be used for obliterating areas on film, or for painting over splices in a sound track to eliminate clicks 94

CABLE RELEASE. An attachment which enables the user to start and stop the ciné camera without touching or jolting it . . 41

CAPTIONS. The main titles of a film, generally excluding names of individuals 87, 92

CASSETTE. Light-tight container or cartridge for holding a roll of film 14, 26–8

CELS. Transparent plastic sheets on which cartoon drawings are traced 94

CEMENT. A liquid which welds two pieces of film together by partly dissolving the surface of each . . . 29, 44–6, 78

CINÉ CLUB. An organization of persons interested in making amateur ciné films; distinct from a Film Society . . . 18

CLAPPER-BOARD. A board and hinged batten, used when shooting a film with lip-synchronization for producing synchronized marks on both picture and sound recording . . . 64

CLOSE-UP. A shot in which the subject is, or appears to be, very near to the camera. This would include head and shoulders only of a human figure 34, 60, 85

COLOUR MATCHING. Filming a colour scene in two different shots, in such a way that the colours appear exactly the same in each 72

COMMENTARY. Explanation, on the sound track, of what the audience sees, usually in a non-fiction film . . . 95, 109

141

ALL ENQUIRIES

relating to this book
or to any other photographic
or cine problem are answered
by the Focal Press,
31 Fitzroy Sq., London, W.1
without charge
if a stamped addressed
envelope is enclosed
for reply.